Paradise City — healing cities with music

Paradise City

healing cities with music

Mario Goossens & Karel Van Mileghem

photography: Fabrice Debatty

 LANNOO

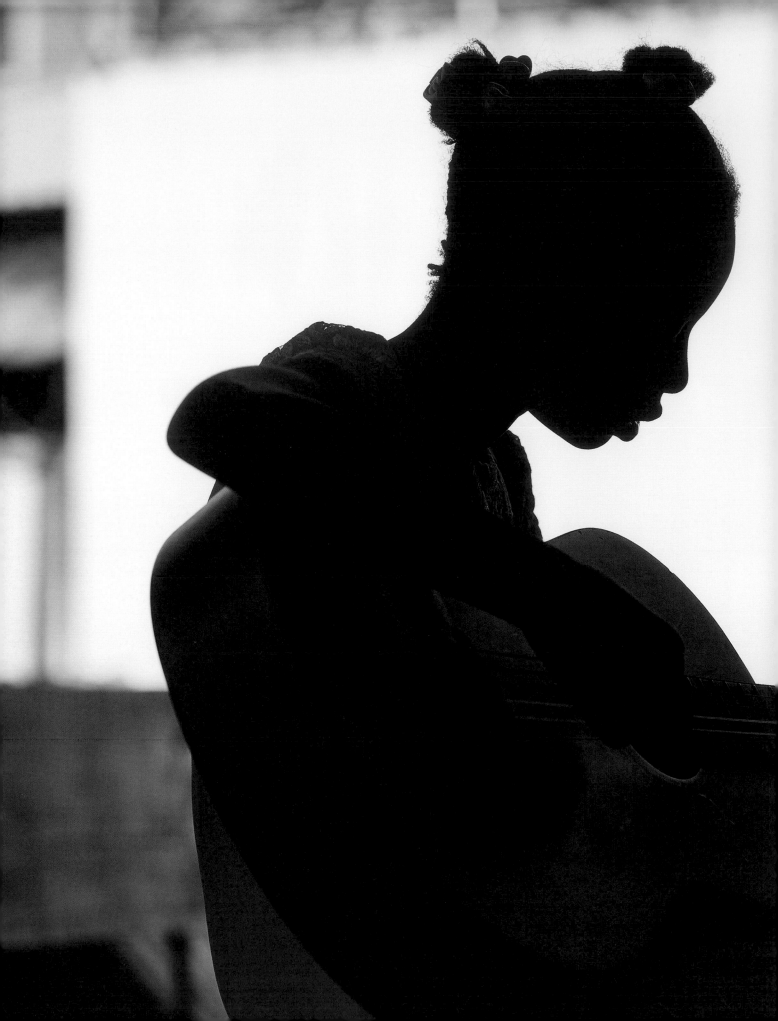

Contents

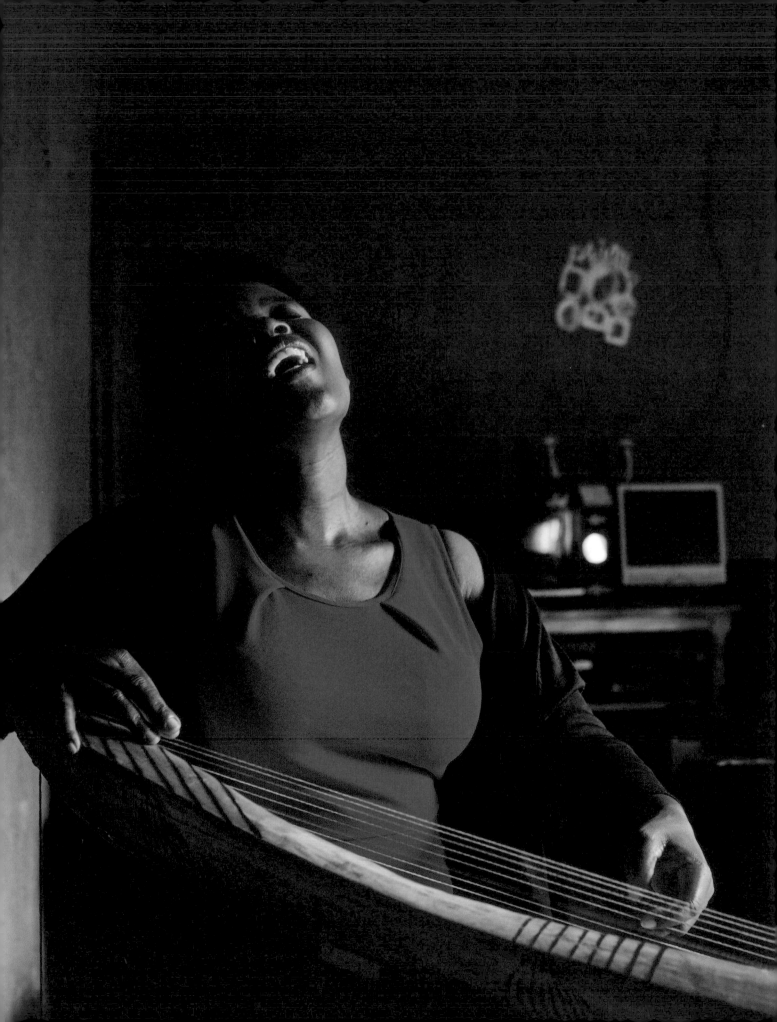

Introduction

Music heals. This may sound like a cliché, but when an entire community is traumatized by horrific events, then it holds true, and music is embodied in its pure healing form; an all-encompassing power of life. Our creativity is often at its best under the most difficult circumstances. Music is in our genes. We instinctively move toward maintaining our emotional balance, and that's when magical things can emerge.

There is clear evidence of this in recent music history. Remarkably, many genres originated in traumatic times; well-known examples include the gospel and blues that comforted slaves in the American South. Genres such as jazz, soul, punk, reggae, hip-hop, techno and rap also originated in communities that endured hardships.

Eventually, these genres appealed to a wide audience and became commercialized, but they originated as a response to the hardships that communities had to face.

Music and misery go hand in hand. This sounds like a contradiction, but it is not: misery makes music, music heals misery. It is a hidden and daily constant in our lives. It is an indispensable part of our quest for survival as human beings.

We wanted to measure the power of music in a microcosm: the city. We chose six cities that have experienced devastating catastrophes, either natural or man-made. Who are the driving forces of music in such cities and, how can music and art heal the wounds of the community?

We traveled to various continents and cultures to visit communities with divergent musical backgrounds. Some disasters played out over decades, such as The Troubles in Northern Ireland, which for years had a stranglehold on the city of Belfast. Other disasters occurred suddenly, such as the New Orleans flood in 2005, which almost drowned the city, and the atomic bomb in Hiroshima three-quarters of a century ago. The witnesses to that living hell were children at the time and are now in the last phase of their lives. By contrast, the earthquake in Port-au-Prince, Haiti, is only 10 years old. The decline of the city of Detroit cannot entirely be blamed on the collapse of the automobile industry. In the Rwandan capital of Kigali, the power of music was deployed as propaganda for a meticulously planned genocide, especially via radio. Rwandans are now trying to use this same medium for reconciliation, and they are succeeding in this effort.

Nothing is what it seems like after a disaster. There is always a narrative that is more subtle than the story told in the media and what remains in our collective memories. In processing the disaster, this nuance plays an important role for the inhabitants, and music is a perfect catalyst for this. It provides the spiritual input for them to hold their heads high and believe again in a future.

This book provides an insight into the underbelly of cities that have scrambled to their feet. We knocked on the back door of each city and discovered hopeful stories. "The healing power of music" instantly stops being a cliché. These are real people. These are real stories. This is real music.

Mario Goossens & Karel Van Mileghem

"There is
a light
that never
goes out"

The Smiths

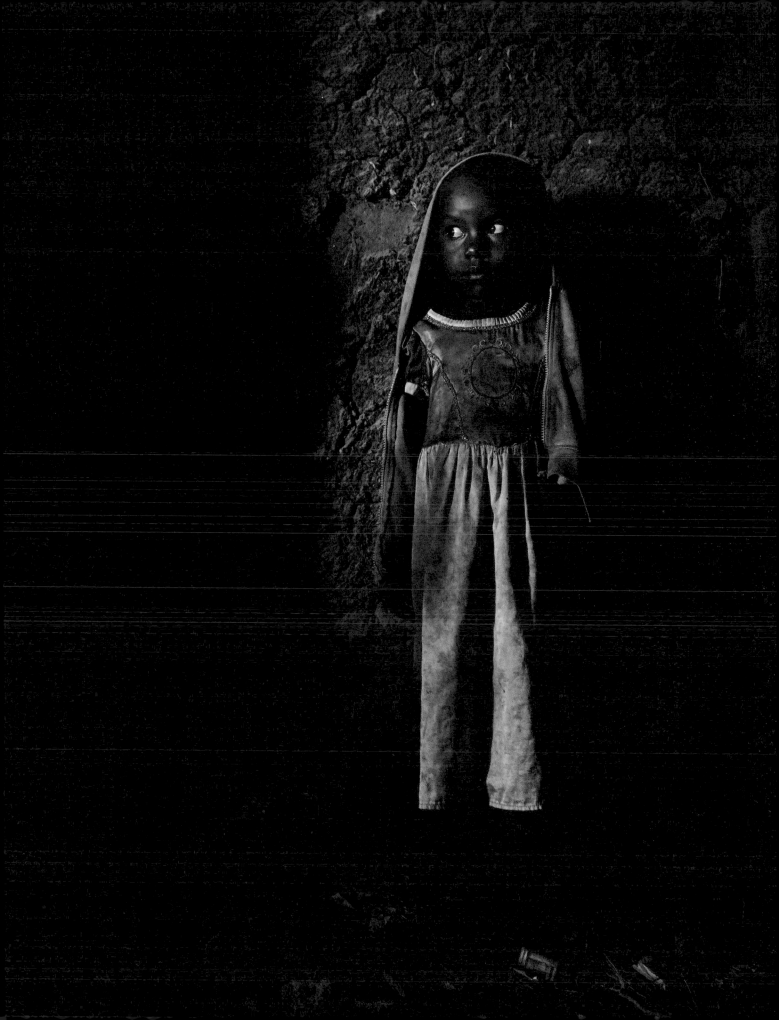

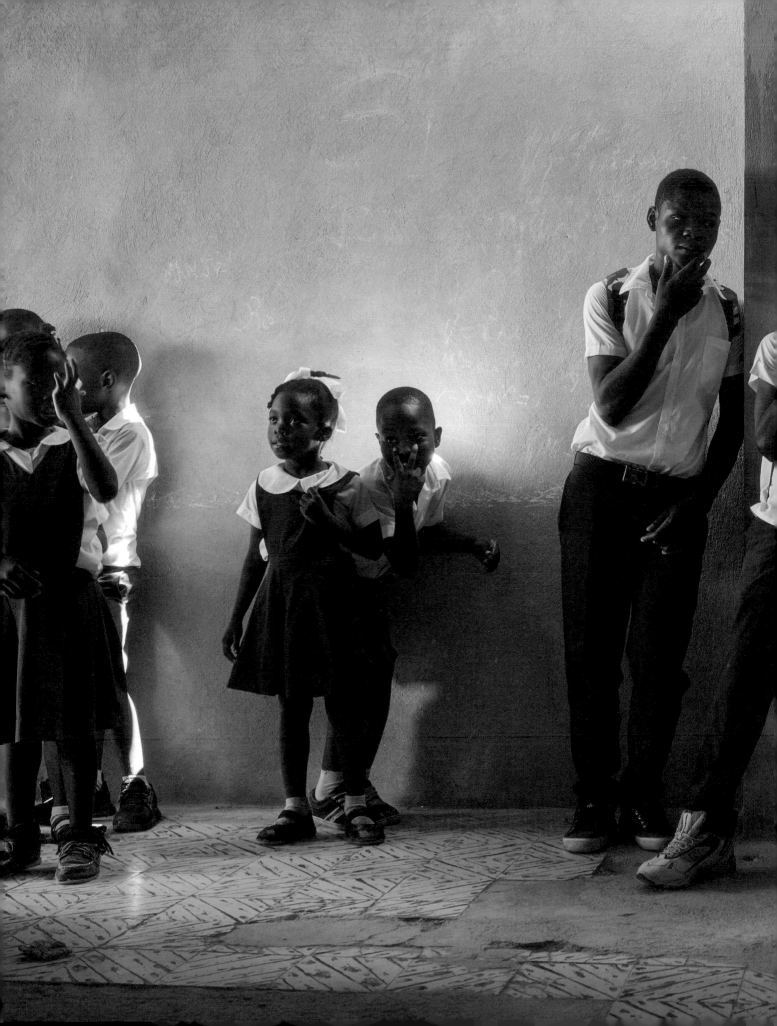

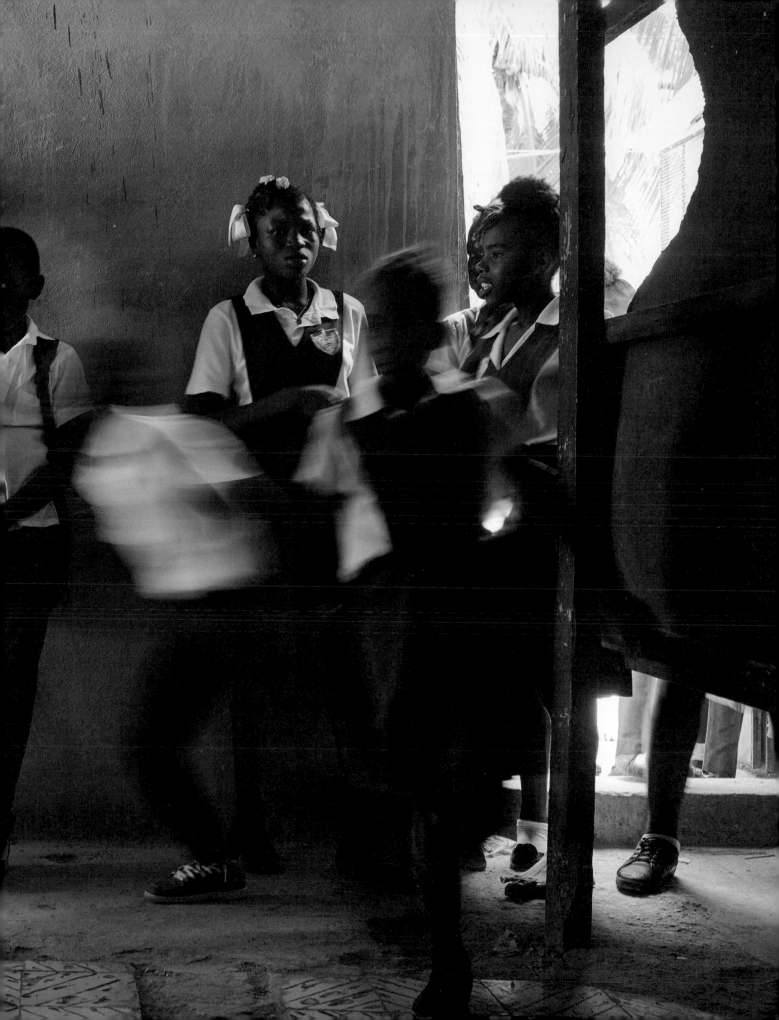

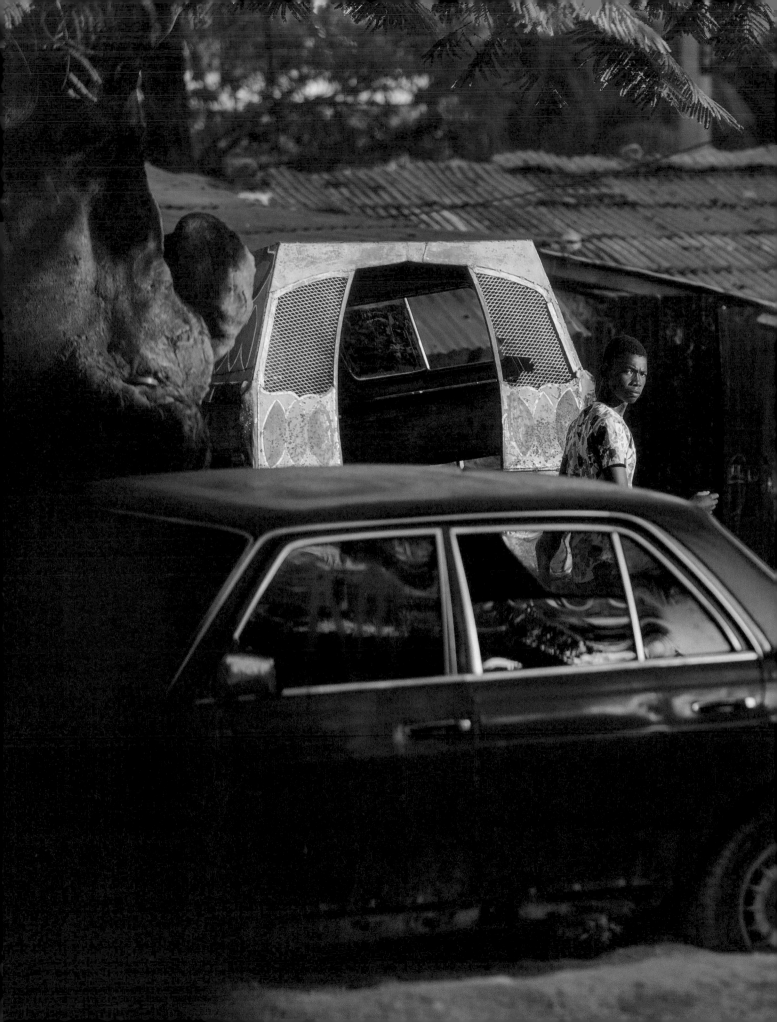

I.
Port-au-Prince

Every time Haiti tries to raise itself up, it gets bashed and sinks further. For centuries, Haitians had taken a beating, and nature dealt them yet another destructive blow on January 12, 2010.

In 1492, it was not the squalor, but the beauty of the area that captured the emotions of Christopher Columbus. The explorer was looking for a new route to India when on December 5 he berthed at a beautiful mountainous island. It was inhabited by the Taíno Indians, who gave this idyllic place several names: Ayiti, Bohio, and Quisqueya. Columbus named it Hispaniola.

Shortly thereafter, Hispaniola was invaded by Spanish conquerors blinded by gold fever. Within a few decades, they had wiped out the native population. The Indians were not immune to European diseases, and those who survived had to toil hard on plantations that were established.

European super powers vied for the division of the New World and France set its eyes on Hispaniola. For years, French pirates had tried to take over part of the island, and ultimately Spain withdrew from the western part. The eastern part became Santo Domingo, which nowadays is the Dominican Republic, and the western part became Saint-Domingue.

The French transported hundreds of thousands of African slaves to work on the plantations. Saint-Domingue became known as the "Pearl of the Antilles," the French Empire's richest colony due to huge profits from the sugar and coffee plantations. But the pearl had its dark side: the African slaves lived in the most appalling and inhumane conditions.

The "Liberty, Equality, Fraternity" of the French Revolution inspired the slaves to rebel, in what became the Haitian Revolution. After a 13-year struggle, the Afro-Creole slaves, under the leadership of Jean-Jacques Dessalines, defeated Napoleon's army and in 1804 declared independence. Haiti became the world's first black-led republic, and the remaining French islanders were gruesomely killed. The first Haitian flag was created by symbolically ripping out the white band from the tricolor French flag.

During the Haitian Revolution, a new music genre emerged: Rara, polyrhythmic music based on cylindrical bamboo trumpets. Added to that were drums, maracas, güiros, and metal bells. Its African roots tie it closely to voodoo rituals. Rara inspired the fighting slaves on the path to victory, and when they finally gained independence, a huge rara celebration broke out in Haiti. This is a tradition that still exists today.

Port-au-Prince became the capital city, but the new republic was not recognized by the United States or by most European states. Dessalines declared himself Governor-for-Life, but two years later he was killed. An ongoing internal power struggle raged, and Haiti changed its form several times. Ultimately, in exchange for recognizing Haiti as an independent republic, the French demanded twenty-one billion dollars for the loss of its colony and slaves, a debt that was fully paid off by 1947.

The US occupied Haiti in 1915 and basically controlled the country. After America withdrew in 1934 it continued to have a strong influence during the 20th century. Later, Haiti fell into the hands of dictators, the most notorious being François Duvalier and his son Jean-Claude, nicknamed Papa Doc and Baby Doc, respectively.

On January 12, 2010, the island, already brought to its knees, was hit by an enormous natural disaster. At 4:53 p.m. local time, two tectonic plates shifted alongside each other under the city of Léogane, close to Port-au-Prince, resulting in a devastating earthquake. An estimated 250,000 houses, not built to sustain tectonic forces, collapsed or were severely damaged. Even a large part of the presidential palace was destroyed. The death toll was enormous: estimates range from 100,000 to 300,000, and mass graves had to be dug. A cholera epidemic broke out. The global humanitarian aid that Haiti received could have meant a new start for the country, but a large part of the collected funds was embezzled. Haiti remains an unstable country where the lion's share of inhabitants live in dire poverty, with little to no basic provisions.

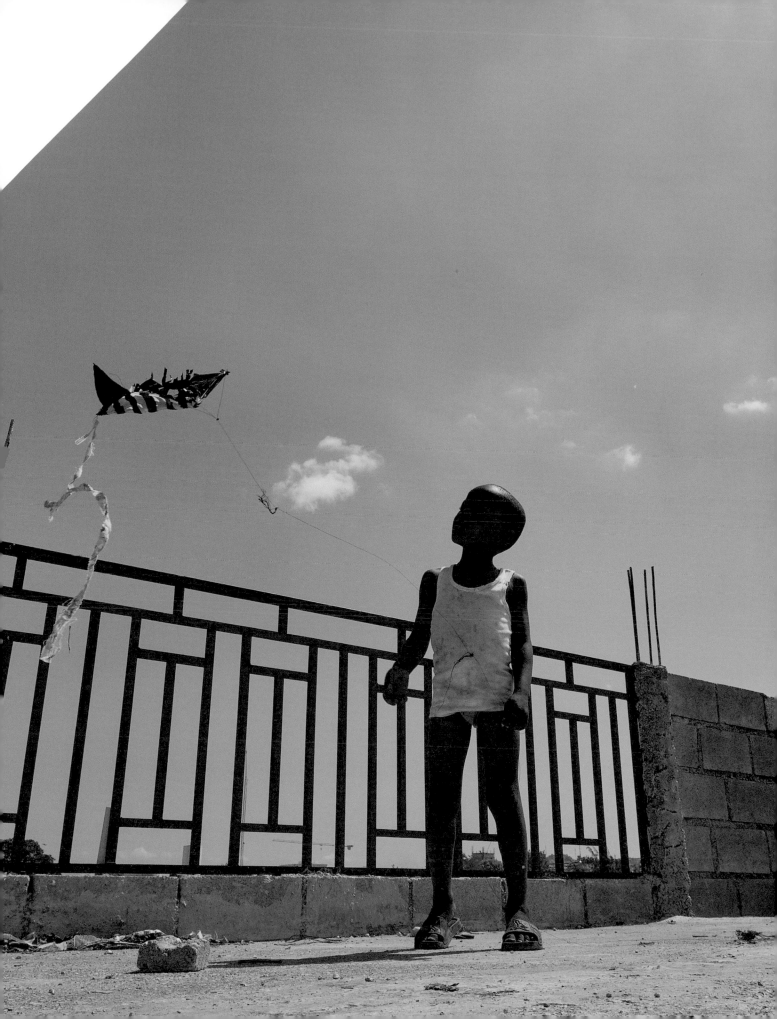

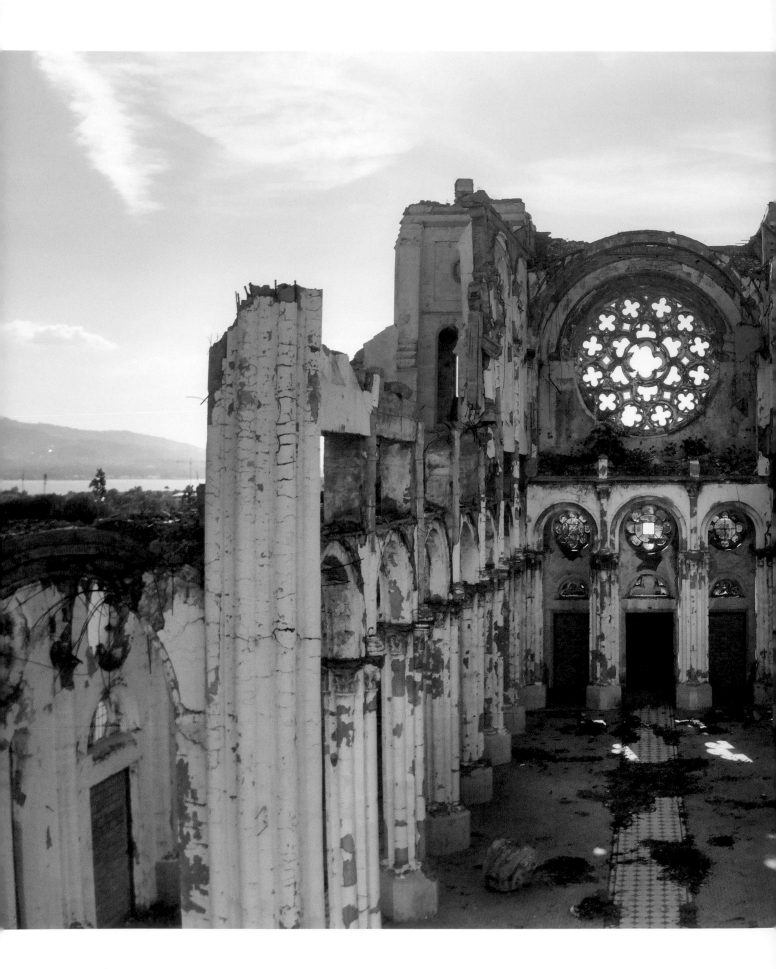

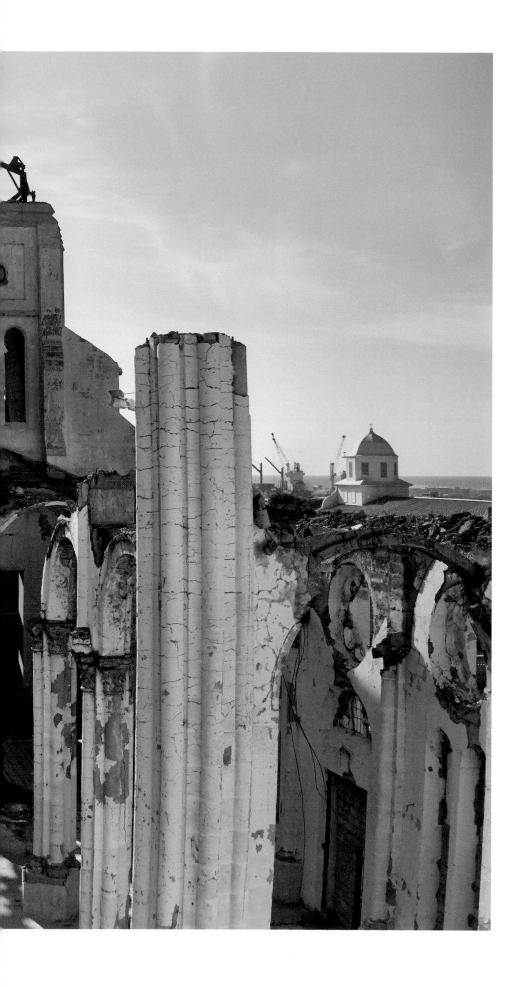

ROMEL JEAN-PIERRE

Romel Jean-Pierre was born in the Grand Rue ghetto neighborhood of Port-au-Prince. Once the commercial hub of the city, the neighborhood was left in shambles by the earthquake, and the economic center of the city was moved higher up the mountain to Pétionville. Grand Rue remained deserted and devastated. The damaged buildings are scarred with cracks from the earthquake, and it is one of the poorest neighborhoods of the city.

Romel was a baby when an American expat fell in love with his mother. The relationship did not last long, but the American considered Romel as a son, and gave him the best possible education away from the ghetto. Romel thought that the white American was his biological father, taking no notice of the different skin color. When Romel's adoptive father died suddenly in 2003, he was brought back to Grand Rue by his father's family with the explanation that he would visit his mother, who he had not seen for years. When no one came to pick him up by evening, Romel realized that he had been dumped.

Romel's new home, which had to accommodate an entire family, was the size of his childhood playroom. He no longer slept on a mattress, but on a carton. His family considered him a snob and rejected him. Romel became introverted and the people of the Grand Rue neighborhood thought he was crazy and backward.

One day on the Grand Rue, he encountered the Atis Rezistans, a collective of urban artists who created voodoo-inspired art from waste and human remains. After the earthquake there were so many bodies that a lot of art was made with skulls and bones.
The Atis Rezistans discovered that Romel could speak English. Feeling appreciated, Romel opened up to the artists and he became their interpreter. In 2009, he met international artists who visited Haiti and a new world opened up for him.

This world collapsed abruptly on January 12, 2010. Romel was in an Internet café on Grand Rue when the earthquake began. He rushed outside with his friend Steven as the building behind them collapsed.

Romel and Steven stood in the middle of the street and held each other tight. In the unfathomable mist of dust, they stood like stone statues surrounded by horrible screams. When the curtain of dust slowly settled, the horrific scenes emerged: arms and legs of people were hanging out of buildings; a child with half his face missing stumbled by. Romel was in the midst of an apocalypse.

After the earthquake, humanitarian aid organizations poured into Haiti. Romel was one of the few young people who spoke English, and he became one of the main witnesses for organizations that recruited funds. Romel was invited to meet with Bill Clinton, Pharell Williams, and Robert De Niro.

In Haiti, Romel invested all his time in the Konbit Mizik Project. It was established as a free record label and music studio for young musicians in Port-au-Prince, but rapidly expanded its activities. They annually organize the Pwojè SIDA, a festival with popular performers in Haiti. Entrance is free, but the festival attendants must take an HIV test before entering. It is estimated that there are 140,000 people with HIV or AIDS in Haiti, half of whom are not tested or treated.

Romel is currently the director of Konbit Mizik and has a new dream: to become the president of Haiti. He thinks the time is ripe for great changes and wants to become an influential figure in Haiti. "We now have independence. It's time to build up our nation," he says.

The once "backward and crazy" youngster now has a powerful voice.

"We now have independence.
It's time to build up our nation."

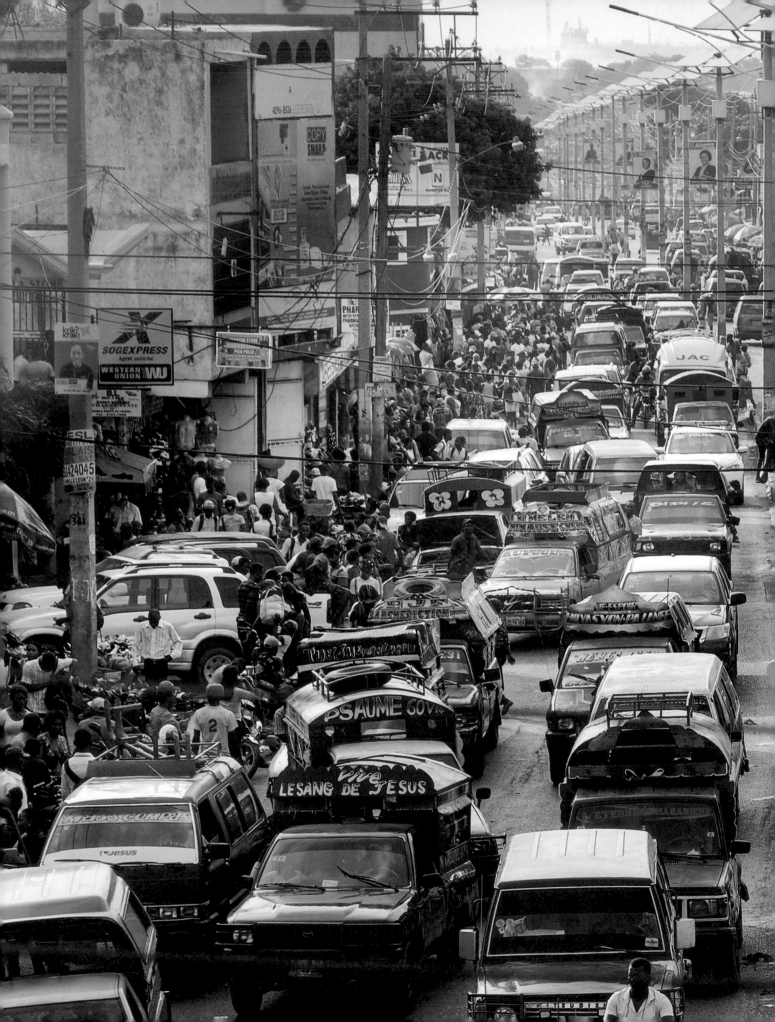

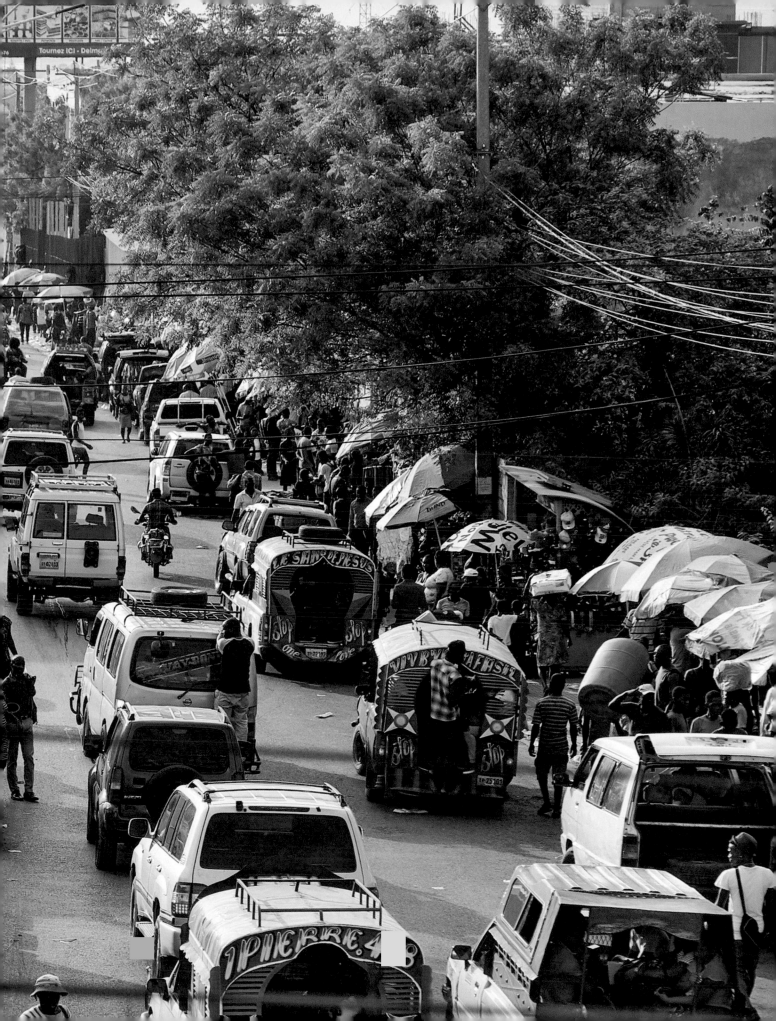

"Music has changed my personality.
After the earthquake I became pessimistic
and music has made me optimistic again."

ABIGAËLLE
JOSE SÉTOUTE

Seven-year old Jose was reading the Bible when the earth began to move. Her mother grabbed her and her sister and brother. None of them understood what was happening because they had never experienced an earthquake. They heard cries of panic on the street, so they remained indoors until a neighbor ordered them to go outside. Their house was about to collapse.

The family lived in Delmas, Port-au-Prince, close to a golf course — a green oasis in a neighborhood overflowing with rubbish. Alongside the houses of Delmas are small ravines bulging with garbage. Occasionally boars and goats search for something edible among the plastic. After the earthquake, many houses in Delmas were uninhabitable. The first night after the earthquake, Jose's family slept in a church and later moved to the golf course. The owners opened the gates, and in no time, a tent camp mushroomed to a population of 45,000 people. Jose lived there for three years until her house was rebuilt. American actor Sean Penn would indirectly play an important role in her life.

Sean Penn was deeply affected by the tragedy of the earthquake and founded his own non-profit organization, the J/P Haitian Relief Organization, now called CORE. The organization focuses on rebuilding the lives of the Haitians by creating healthy and safe neighborhoods and improving infrastructure and education. Schools were established in Delmas. CORE's School of Hope is one of the only schools in the country to integrate both abled and disabled students.

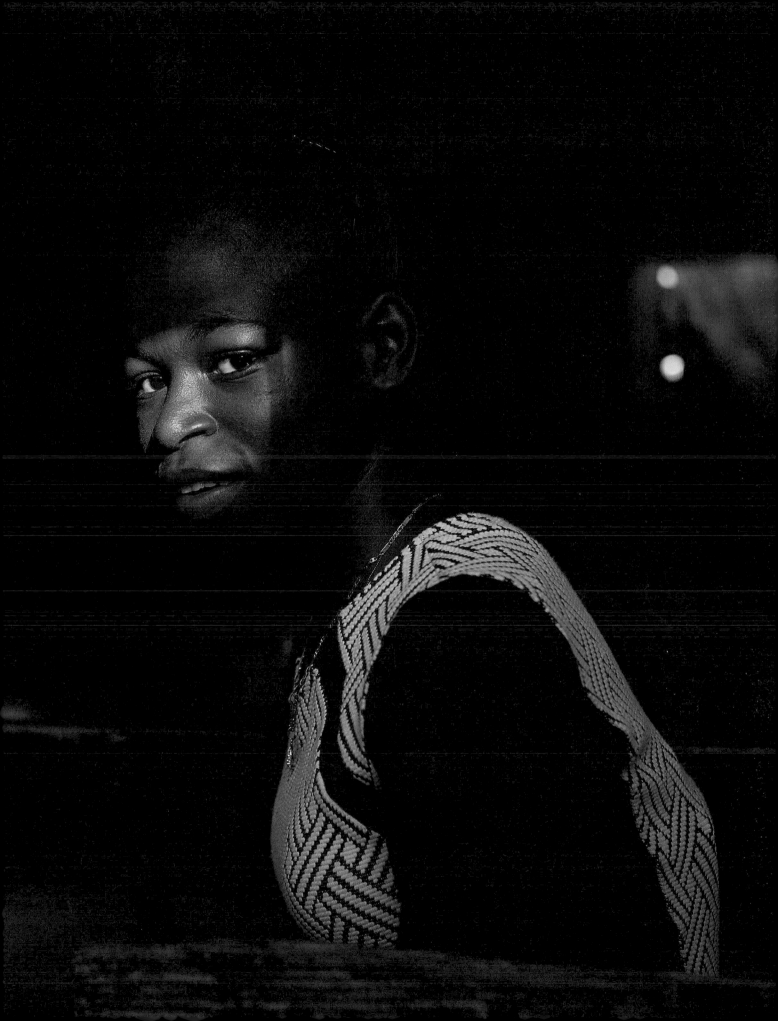

One day, Jose was at a playground with her friends when she suddenly felt an enormous jab in her heart. She collapsed and could not respond when her friends asked her what happened. As soon as she was able to stand up, she went home. To her surprise, she found the entire neighborhood standing outside her house. One of the neighbors pulled her away. He wanted to spare her the sight of her mother, who had just died. Her mother had returned from the market and had a heart attack a few feet from the front door. "I never saw my mother again. I don't even know where she is buried. My father said that it is bad luck to visit her grave, because that way he would never find a new wife."

Just when Jose had put the experience of the earthquake behind and her life was back on track, she lost her mother. The smile on her face disappeared and she totally withdrew into herself. At home, her deceased mother was no longer mentioned and Jose was sucked into a downward spiral.

Then one day, she heard of a new after-school activity. Music Heals International, a partner organization of CORE, brings music education to communities in Haiti. There were 65 places available and Jose registered. She was enchanted by the sound of the piano and chose that as her instrument. Slowly but surely she regained her smile. For Jose, the music lessons were far more important than academic lessons. "At school I did learn geography and history, but what I learned during the music lessons was far more important. I am optimistic again and I have a lust for life."

Today, the project consists of more than 425 music students who rehearse twice a week playing musical genres they love in ensembles. Jose is progressing well and even occassionally leads the ensemble. Thanks to her talent, she gets private lessons in classical piano. In the future, Jose wants to attend a conservatorium; she wants to make music her life, and she dreams of running her own music school.

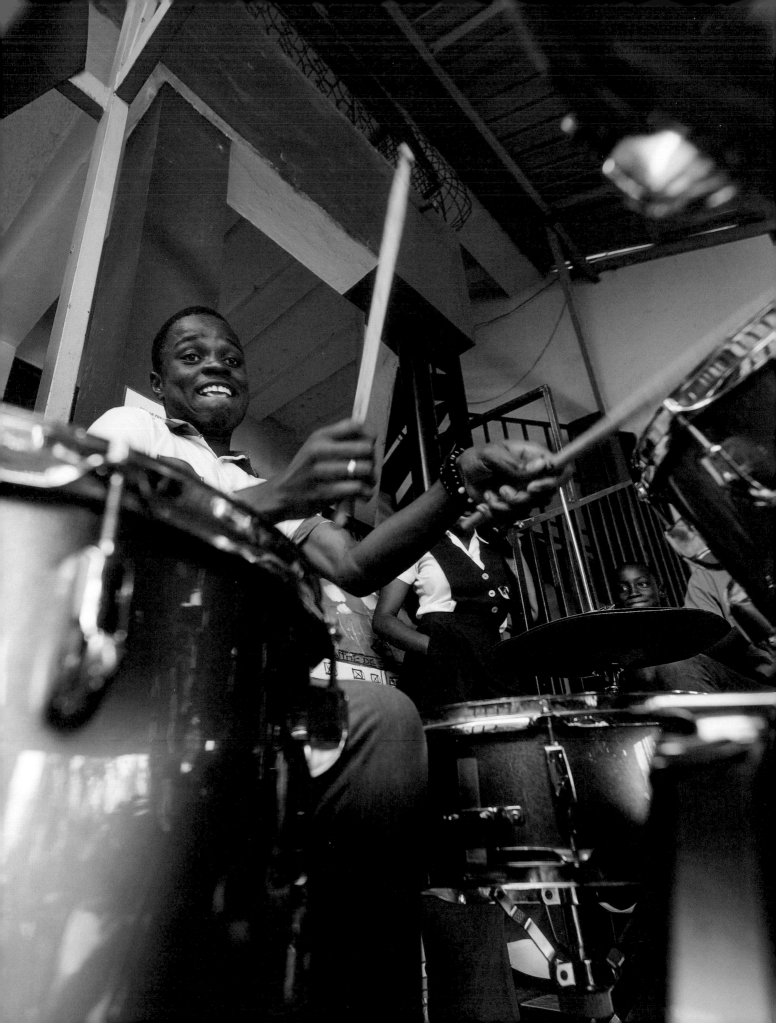

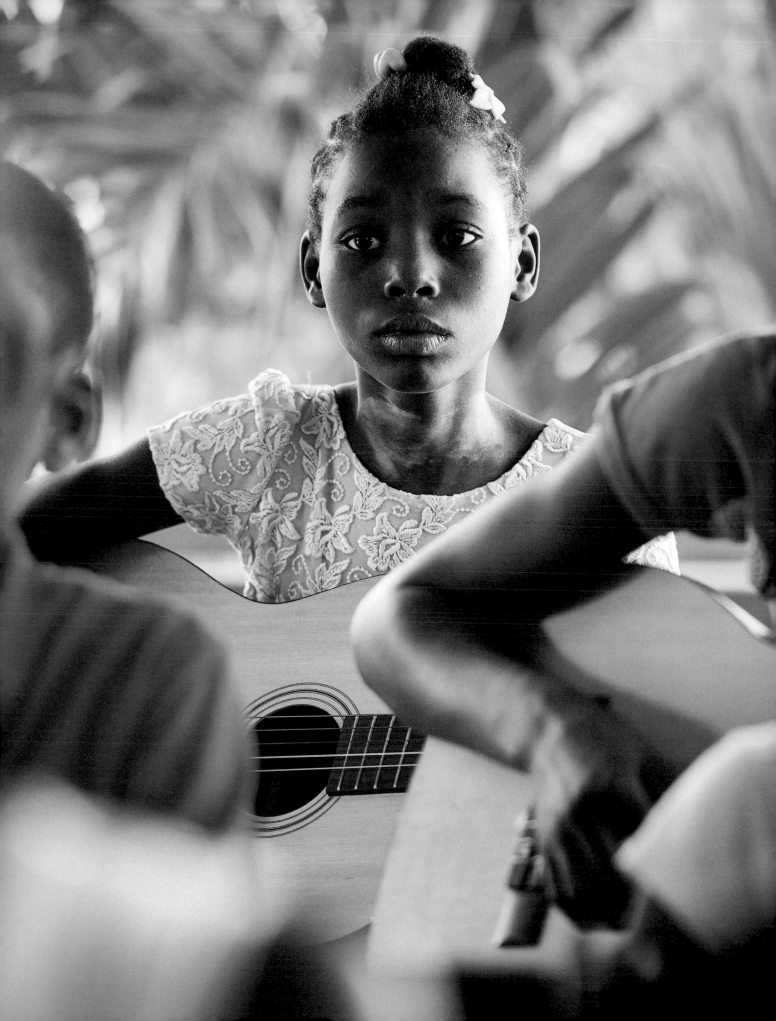

ZIKIKI ST. ELOI

Zikiki lives in the slum of Carrefour Feuilles. He hails from an artistic family that has transformed their steep side street into a street of art. The walls are painted, the staircases are finished with mosaics, and there is a statue on the street of Jean-Jacques Dessalines, the first black leader of Haiti. The artistic vibe dispels the gloominess and roughness of this slum. The family promotes art and sports to help the neighborhood progress, and these efforts are appreciated — their street is named after the family: Imp. St. Eloi.

One of Zikiki's uncles is a soccer coach, and another teaches sculpture. His father is a painter, and Zikiki focuses on music. Climbing up the steep road, one finds a small plateau with a breathtaking view of the city and the Caribbean Sea in the background. If the neighborhood wasn't so dangerous, it would be a tourist attraction. On the plateau Zikki's family has built a small school for children from the neighborhood.

For Zikiki, art is a compass that leads children on the right path in a neighborhood terrorized by street gangs. Young rascals grow up into gangsters, gunshots are heard on a daily basis, and the residents live in fear. Gang wars sometimes rage so fiercely that school lessons have to be cancelled. Zikiki is angry at the government, which he holds responsible for sponsoring the gangs with money, weapons, vehicles and food. Haitians are responsive and take to the streets when they don't like something. The government wants to confine protest and uses the gangs as a muzzle. Zikiki works hard to stop these fraudulent investments and to channel the money into education. He wants to expose children to a positive way of life before they are given weapons. "Once a kid gets his hands on a weapon, he will never give it up," he says.
Zikiki is convinced that an artist can gain respect from children and can offer them other options.

The earthquake was traumatic for Zikiki. When the trembling started, Zikiki was sitting in a taptap (a small bus with parallel benches), together with Mirla, the singer in his band. Suddenly, they felt the earth move. Mirla was about to jump off the bus, but Zikiki held her back. Had she jumped, she would have landed where two cars collided. Mirla was so impressed with Zikiki for saving her life that she later married him.

Once the taptap came to a halt, they continued on foot to Carrefour Feuilles. The house of Zikiki's neighbor across the street had collapsed, and children were trapped in the debris. Zikiki and his friends, like possessed souls, began to dig, and they saved six children from the rubble. Two children had crawled under a cupboard for protection and were trapped. Their crying and calls for help were bone-chilling. Zikiki and his friends lacked the equipment to free them, and they had to give up on these children in order to help others.

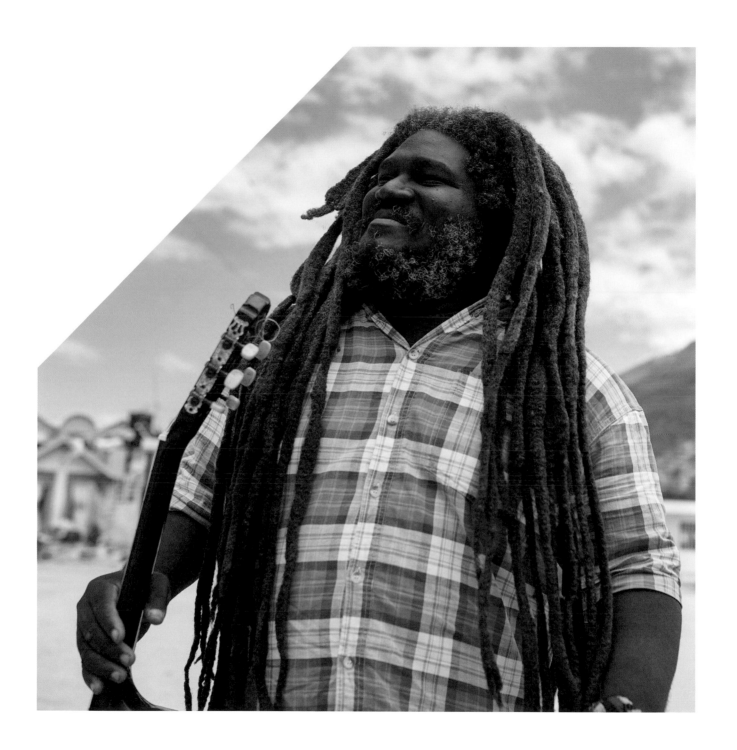

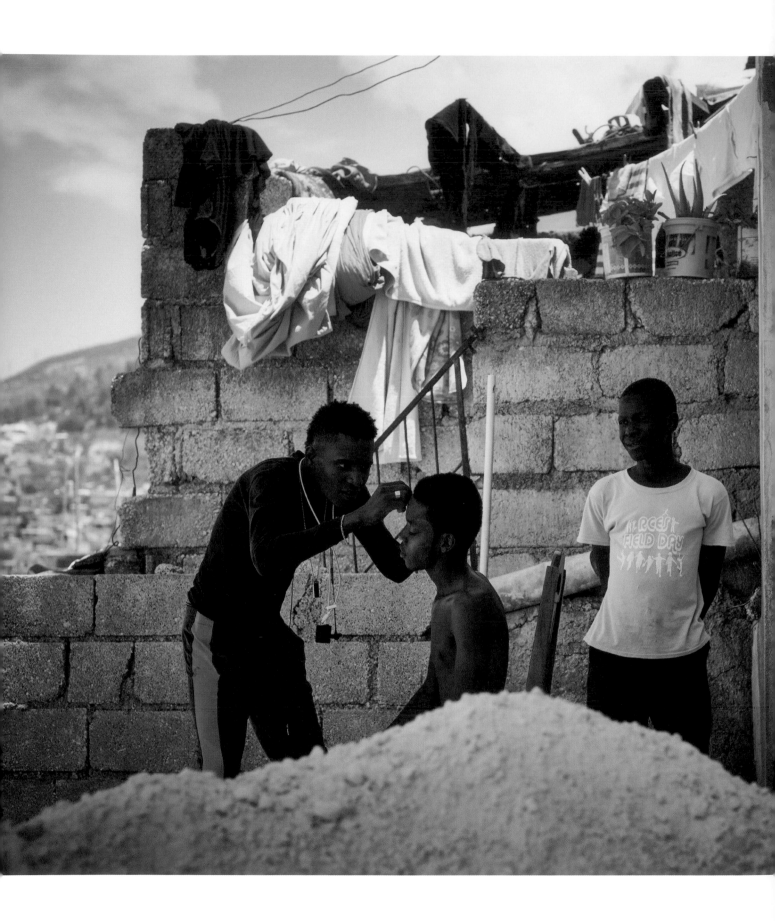

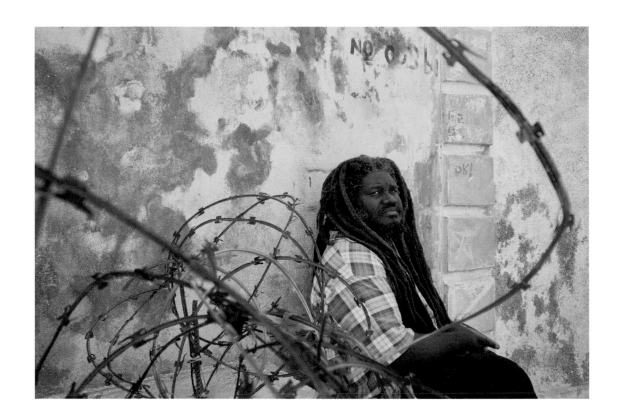

Zikiki remained all night at the site comforting the children, their voices softly fading away until they became totally silent. That night had a severe impact on Zikiki. For six months, he suffered from a recurring nightmare: he attempts to pull the children from under the rubble, but they die. He is only 27 years old, yet already has a graying beard.

Music helps to process the trauma. Zikiki realized that, like him, children in the camps needed a positive diversion. That's why he started music lessons, which led to the establishment of a small school. It annoyed him that lessons often had to be cancelled due to violence and danger in Carrefour Feuilles. As a positive voice of the neighborhood, Zikiki felt threatened by the gangs; he even considered hiring a bodyguard. He directs his pressing question to the greedy government: "How much more money do you need before you let us lead a dignified life?"

"Once a kid gets his hands on a weapon, he will never give it up."

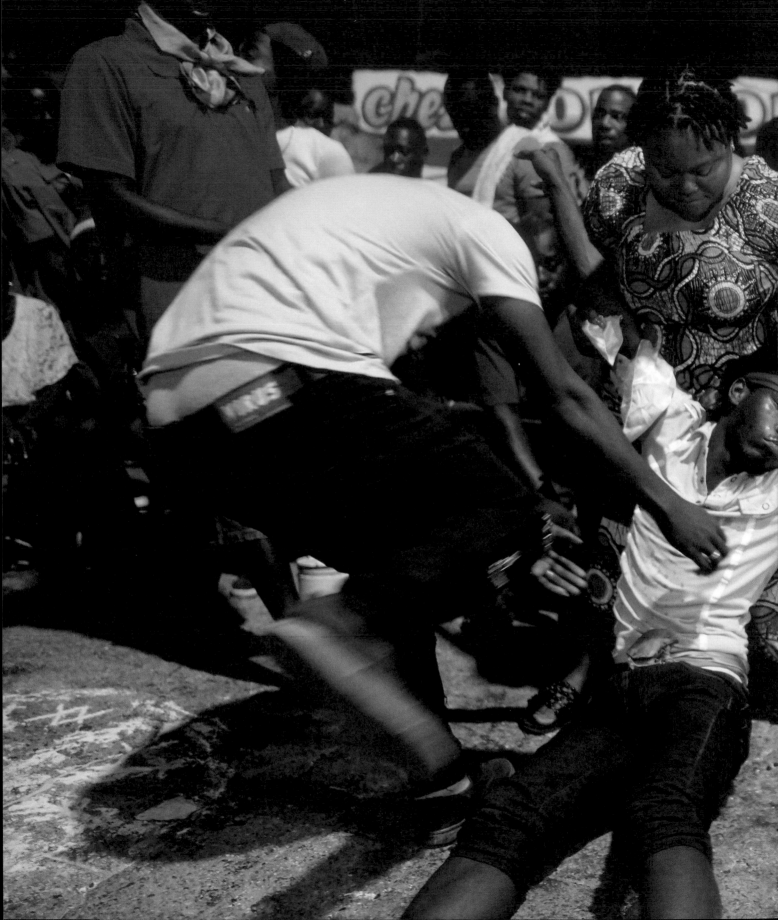

YVES-MARIE CROICOUX

Yves-Marie Croicoux is the founder of the music band Raram. The band plays rara, the traditional music of Haiti, which is strongly tied to voodoo culture. Rara was to the Afro-Creole slaves what blues was to Afro-American slaves. They drew courage and strength from rara during the agonizing work on plantations. When Haiti gained independence in 1804, a rara celebration broke out, representing Haitian victory, freedom and pride.

Yves-Marie Croicoux grew up in the Bel Air neighbohood of Port-au-Prince. Long ago, it was a bourgeois neighborhood with stately colonial houses. Today, it is one of the poorest and most dangerous neighborhoods in the city and was hit the hardest by the earthquake. However, it is a neighborhood full of artists, where rara and voodoo play a central role in the life of its inhabitants.

Raram was established in 1993 and became one of the best-known rara bands in Haiti. The rara season falls around Easter and is part of the procession during voodoo ceremonies, which the rara bands must protect. People flock to the streets and conduct rituals with fire, knives and whips, accompanied by rara musicians. The ceremony lasts all night long; villagers fall into trances and are possessed by spirits as they roll uncontrollably on the ground. For spectators, the ceremony is intimidating; it seems to be completely out of control when the participants besiege each other with knives. But they don't actually stab each other.

Around Easter time, the rara bands march along the dark streets of Port-au-Prince. Raram marches at the head, and the music entices people out of their homes. In no time, there are thousands of people in the procession, forming a rollicking human serpent. Enthusiastic spectators shoot revolvers into the air to the rhythm of the music.

Yves-Marie is proud of Raram, and the band is his life. "Slavery may have ended two hundred years ago, but in our minds we still feel scarred. Rara gives us a sense of freedom." Yves-Marie changed the band's name to Raram International following a tour in the United States at the end of 2009. However, the euphoria of the trip diminished rapidly when, a few days later, the earth rumbled. Raram was badly hit; some of its musicians died or were severely wounded. Yves-Marie was home with his three-year-old daughter, who died under the rubble. The damage was so great that her body was never found. "I lost control of myself. The streets were littered with the dead. I saw one truck after another pass by, loaded with bodies. At one irrational moment, I jumped into the road intending to throw myself under the wheels of one of those trucks, but fortunately I stopped myself in the nick of time." Yves-Marie sat crying in a corner for an entire year before he found the energy to get hold of himself. He began to write songs to comfort and lift up his community. The profits from the concerts performed by Raram went to the people of Bel Air. They used the money to buy food, repair tents and build new houses. These initiatives made Raram hugely popular in Haiti. They spread not only rara, but also hope. "By now we have processed lots of grief, and yet, every time I think of my daughter, tears roll down my cheeks."

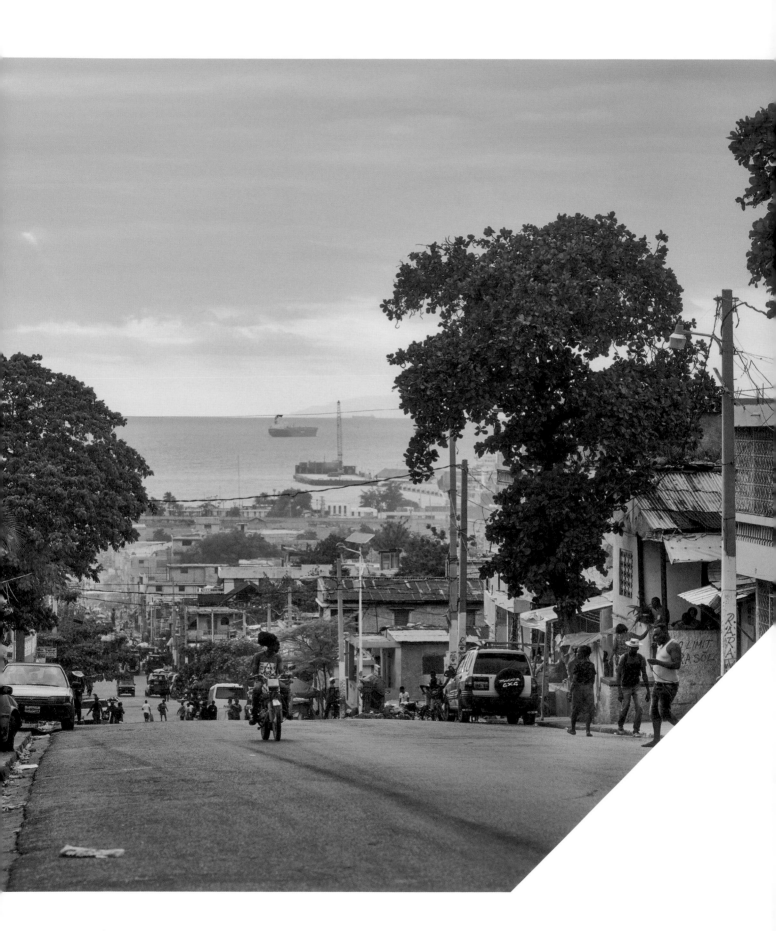

"Even if we were freed from slavery,
we still feel scarred. Music makes us free."

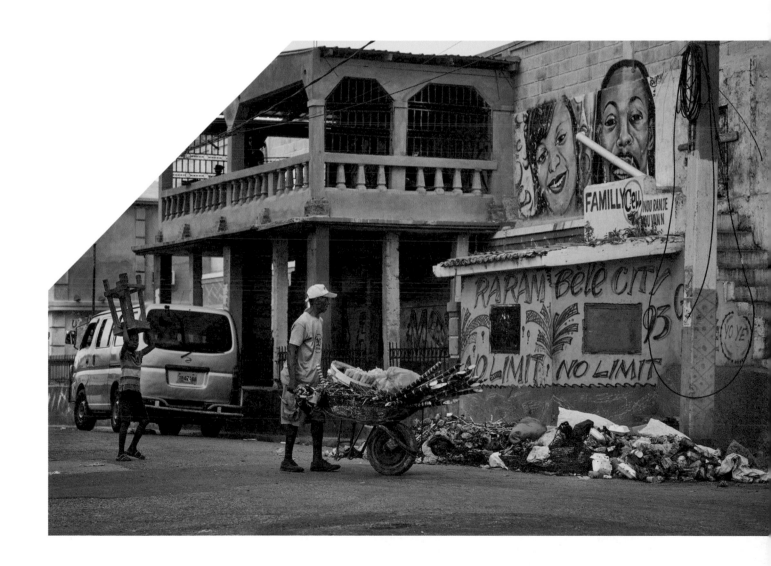

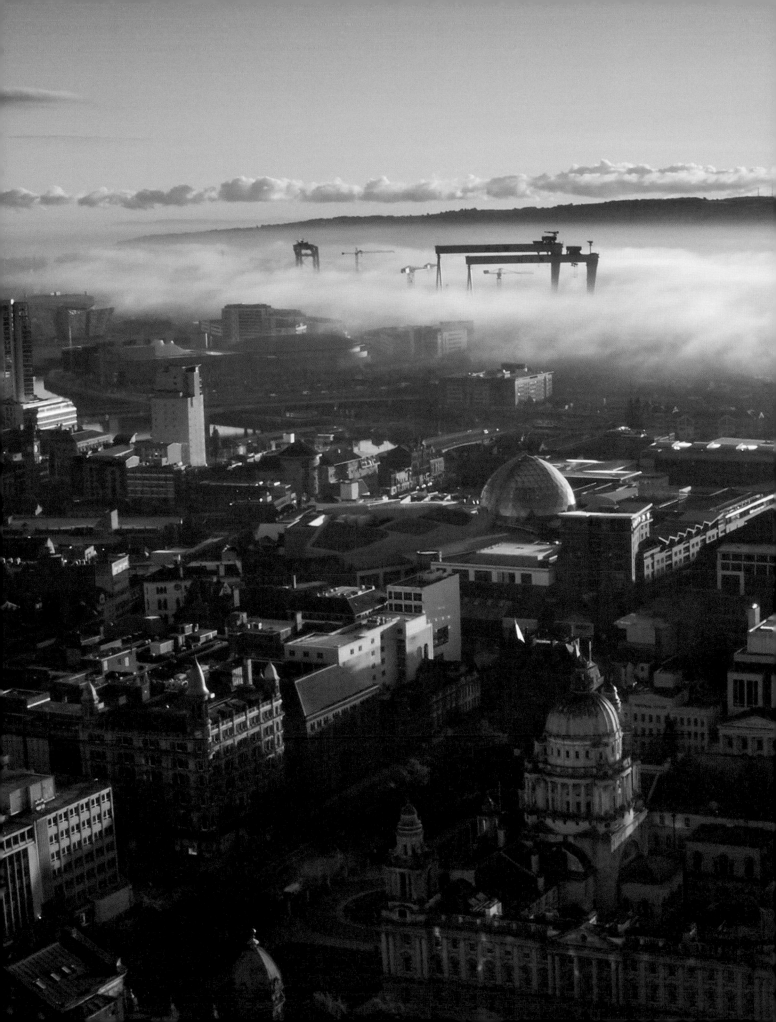

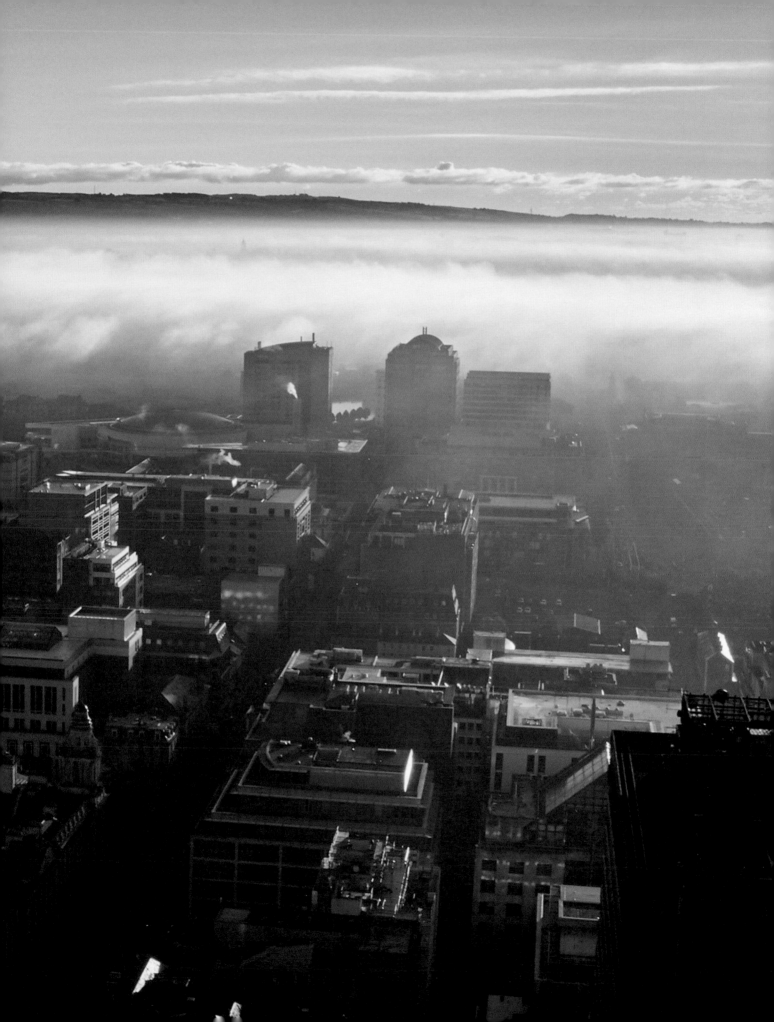

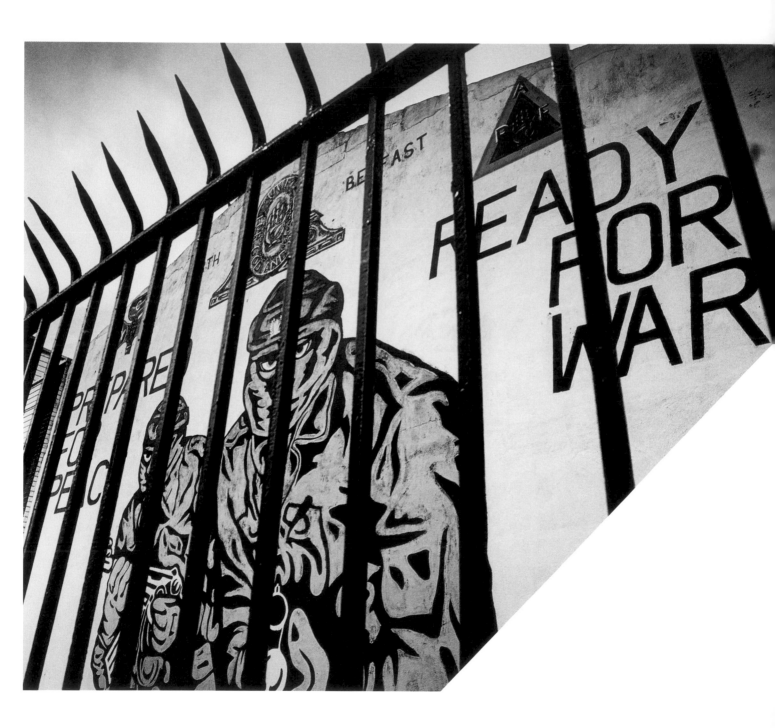

II. Belfast

Belfast has a hip and trendy center with cozy restaurants, authentic pubs and a lively music scene. The city likes to promote itself as the birthplace of the Titanic.

The Northern Ireland conflict seems like a dark past that Belfast has long left behind. Yet, in neighborhoods outside of the center, wall paintings depicting armored men wearing balaclavas invoke a tense, even frightening atmosphere. In Belfast's underbelly, mistrust still bubbles up as paramilitary organizations thrive under the radar. The Brexit referendum in 2016 exposed the continuing ideological contradiction: 88% of Catholics voted against leaving the European Union, while 66% of Protestants voted in favor. Nowadays, the two communities are still separated from one another by a system of walls, known as the "peace walls."

The heat of violence that literally burned Belfast began hundreds of years ago. Already, there was a religious war on the Irish island between the native Irish and the British, who were more than eager to colonize it. Throughout the centuries, England had a strong influence on the island; in 1541, the famous English king, Henry VIII, was even hailed as King of Ireland.

After World War I, Irish soldiers returned marred but emboldened from the front and set up the Irish Republican Army (IRA). Once and for all, they wanted to set matters straight and to drive out the British from their island. After a three-year guerrilla war against the British army and Protestant paramilitaries, their rebellion succeeded. In 1922, an area comprising five-sixths of the island of Ireland was declared an independent state, becoming the Republic of Ireland. In the north, a large part of the province of Ulster remained undecided, but the strong influence of Britain ensured that it joined the United Kingdom. Since then, this area has been referred to as Northern Ireland.

After a centuries-long conflict, peace was restored. Yet in the north, the seeds were sown for a contentious civil war between the Catholic nationalists, who felt strongly tied to the Republic of Ireland, and the Protestant loyalists (or unionists), who swore their allegiance to the British monarchy.

Who precisely was responsible for the escalation of the conflict depends on which camp you talk to. One thing is for sure: the conflict broke out openly in the summer of 1969.

The conflict in Belfast escalated after Bombay Street, in a Catholic area, was burned down by a loyalist mob. It wasn't long before both sides suffered casualties, and Northern Ireland found itself in the midst of a religion-inspired conflict that was euphemized "The Troubles."

Belfast became a ghost town. After business hours, public life came to a standstill. Pubs closed their doors and everyone returned to their own barricaded neighborhoods. The music of Northern Ireland also disappeared. In the 1960s, Belfast had more than 80 concert halls where giants from all over the world performed. Inevitably, musicians also became targets in the ruthless conflict. Following an attack by the Ulster Volunteer Force (UVF) loyalist paramilitary group on the popular Irish band The Miami Showband, no bands dared to perform in Northern Ireland any longer; the bloodbath buried the entire music scene.

In the late 1980s and early 1990s, peace talks began intermittently. Attacks impeded progress, but on Good Friday of 1998, the British and Irish governments finally reached an agreement: The Good Friday Agreement.

Nowadays, there are once again music clubs, restaurants and pubs in the center of Belfast. It almost seems as if The Troubles never happened.

However, some areas of the city, especially working-class neighborhoods, are still reeling with mutual distrust. The peace walls cover about 13 miles of the city and are more than 16 feet high. Residents living adjacent to the wall have built metal conservatories in their back gardens to protect their homes from projectiles flung over the wall. There are small Catholic enclaves in Protestant neighborhoods and vice versa. People in those homes live behind high walls. Many do not dare walk to the other side.

Although the Good Friday Agreement has held for more than 20 years, it remains fragile. Northern Ireland has taken great strides to recover, but the scars have not disappeared.

The conflict has inspired many musicians. A number of notable songs from a very long list include "Sunday Bloody Sunday" (U2), "Zombie" (The Cranberries), "Through the Barricades" (Spandau Ballet), "Give Ireland Back to the Irish" (Paul & Linda McCartney), "Belfast Child" (Simple Minds), "The Luck of the Irish" (John Lennon), "Invisible Sun" (The Police), "And The Healing Has Begun" (Van Morrison), "Belfast" (Elton John), "Blinded by Rainbows" (The Rolling Stones), "Alternative Ulster" (Stiff Little Fingers), "Belfast" (Katie Melua), "Unfinished Revolution" (Christy Moore) and "Belfast" (Boney M).

And so, ironically and unintentionally, The Troubles, which always targeted musicians, influenced music history in a positive way.

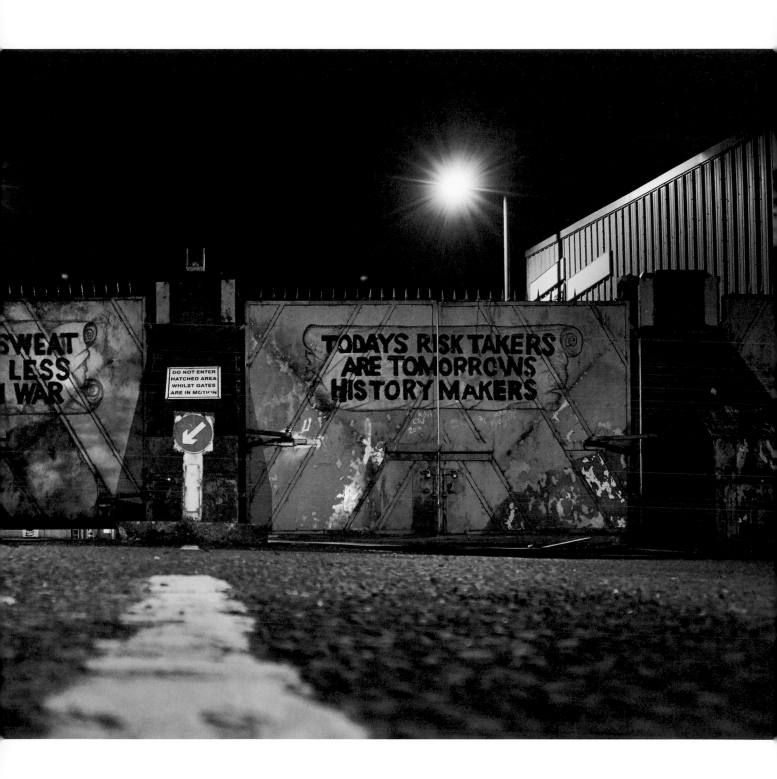

JOBY FOX

Joby Fox grew up in a working-class neighborhood of Catholic West Belfast. He was the sixth child in a family of ten. It's no coincidence that native Irish live in west Belfast. Hundreds of years ago, the English lords took for themselves the higher grounds of east Belfast with direct access to the docks. The west of Belfast with its low-lying bogs and marshes was "good enough" for the Irish.

Joby was still a child when The Troubles broke out in 1969. When his older brother, in his frustration, set a bus on fire and was sent to jail, the British army targeted his family. Raids on their home became standard procedure. Joby's mother had to quickly open the door when British soldiers came around, otherwise they would break it down.

During one of the raids, Joby was lying sick in bed and woke up from the commotion. When he opened his eyes, the barrel of a British machine gun was against his head. This incident turned Joby into a radical teenager, who took every opportunity to attack British soldiers. "Back then I had a framed mind: fuck up the British army at any available moment."

Joby devised a catapult and trained for hours in the woods, learning how to shoot precisely using large staples. He would hide in one of the small streets of west Belfast and wait for British tanks to roll by. He knew that at the front of the tank, a soldier looks through a small opening, and that his eyes are visible and vulnerable. At the right moment, Joby would jump out of his hideout and shoot with his catapult in the direction of the tank. The staple would hit the soldier right between the eyes, and Joby would start to run. He would hear the sound of boots chasing him, but Joby always managed to escape.

The Irish Republican Army was very popular in the 1970s. West Belfast suffocated and many young Irishmen joined the IRA. Joby, too, began to think about this idea. "We were living in an open prison. So I was in the periphery of joining the IRA. But luckily, music saved me."

In that period, Joby heard a band rehearsing in a garage, a seemingly meaningless event, but one that would change his life. Music had an irresistible appeal to Joby. He learned to play the guitar and to sing and was able to re-channel his negative emotions without the use of a catapult.

Music broadened his worldview and awakened his curiosity about his Protestant neighbors. He knew there was a metal door in the peace wall that could simply be opened, but that no one dared to walk through. Yet, with the spirit and naiveté of a young man, Joby went for a walk on the other side. Nothing happened, so he did it a second time. A Protestant approached him, warning that he had better not cross the wall again. Joby, however, did it a third time. The same Protestant gave him a final warning: "Next time, you'll get a bullet in your head."

> "We were living in an open prison. So I was in the periphery of joining the IRA. But luckily, music saved me."

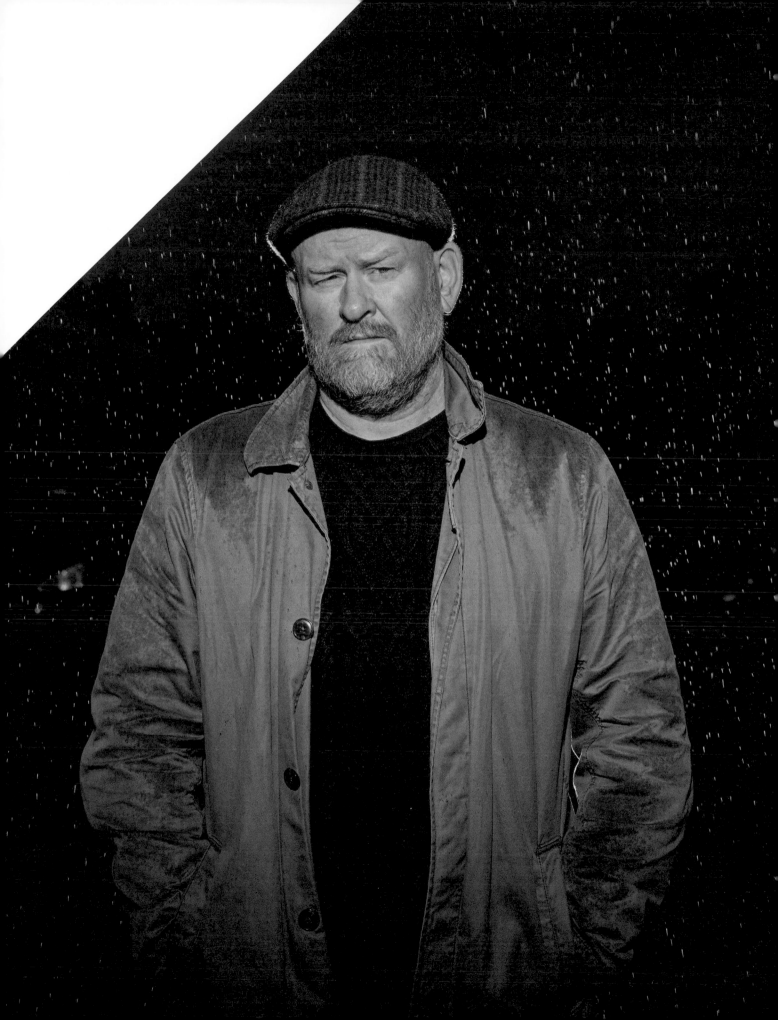

Music did, however, lead Joby safely to the other side. He became a roadie for a Protestant musician and later began to play music himself. Among musicians, it didn't matter much which side you came from. As a performer, Joby withdrew from the radical underworld of west Belfast and felt much better about himself. At the end of the 1980s, he established a band called Energy Orchard, whose debut single, Belfast, became a hit in the UK:

"Bel- Belfast, how I know you so well. You're like heaven, you're like hell."

Joby is a well-known personality in west Belfast, approached by everyone on the street. He plays music at events that aim at uniting the city, yet going to the "other side" still strikes a raw nerve in him. According to Joby, there are things that you can understand about Belfast only if you have lived there long enough and are aware of the sensitivities. Saying one wrong thing to the wrong person can lead to a bad ending. More than 20 years after the Good Friday Agreement, Joby still remains on his guard in the bizarre reality of Belfast.

"Nobody gives a shit when you get beaten up. It won't make the news that you have to recover for months. Maybe when they kill you it will make the news. But after 48 hours, everyone has forgotten. They'll say: Joby was a nice fellow — what's for breakfast?"

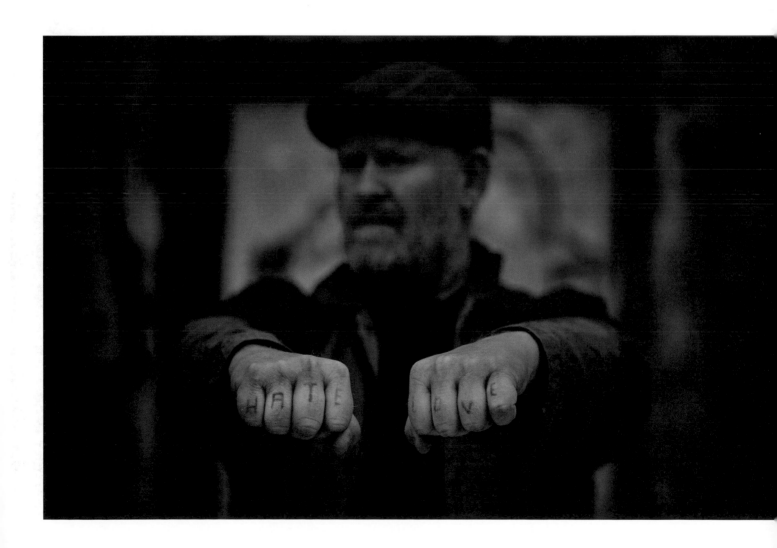

TERRI HOOLEY

Terri Hooley was born in the right place at the right time. He was a teenager in the 1960s and his life purpose was to be a hippie. Adopting ideologies for improving the world, he protested in Belfast against the Vietnam War and campaigned for civil rights. That went hand in hand with stimulants and music. In those days, an up-and-coming band — Van Morrison & Them — would perform weekly in Belfast. Terri saw them play every Friday in one of Belfast's many music clubs. "And when you got a cuddle and a kiss from a girl, that was great. And everyone took the 11 o'clock bus home."

However, in 1969, things changed dramatically in Belfast. While the hippie movement experienced its heyday worldwide, Belfast became gripped by The Troubles. "In the sixties everything was colorful, and the seventies everything was so black and white. It was horrific."

Terri's way of life was not consistent with the contentious conflict all around him. He saw how so many of his friends, who just a few years earlier had walked with him at freedom marches, become radicalized members of paramilitary groups. Terri was Protestant, but didn't choose a side. That's why he became a target for both the Protestants and the Catholics.

One evening in 1970, Terri was attacked by three Protestant men who dragged him into a car. He immediately understood what was happening, because friends had disappeared this way and had never come back. Fortunately, two acquaintances witnessed the near-abduction and came to his aid. Terri managed to escape, and that same evening he made a courageous, yet bizarre, decision: to open a record shop.

Of all places, Terri opened his Good Vibrations record shop on Great Victoria Street, which had suffered the most attacks. The shop had difficulty getting started, but then Terri came in contact with the new punk movement that propagated the ideals of his hippy youth. One evening in 1978, Terri went to the club The Pound, where the Belfast punk bands The Outcasts and Rudi were performing. When the Northern Ireland police, the Royal Ulster Constabulary (RUC), came into the hall, Rudi's lead singer, Brian Young, yelled through the microphone "SS RUC, SS RUC, SS RUC ..." The police cleared away, but came back reinforced by the army. The punks found themselves facing an unequal fight, and this is what Terri had been waiting for: fearless musicians who dared to declare anarchy. That same evening, he impulsively offered Rudi a record contract, and the Good Vibrations record label was born.

Terri started organizing punk concerts at the Harp Bar. During the day, this was a striptease bar; in the evenings, when no one dared to go to the city center, punk concerts were held. Terri is convinced that the punk movement saved many young lives. Instead of joining the paramilitaries, young people came in to bang their heads on raw guitar riffs. More and more young people visited his record shop, which gave rise to a new counterculture amidst the tanks and bombs.

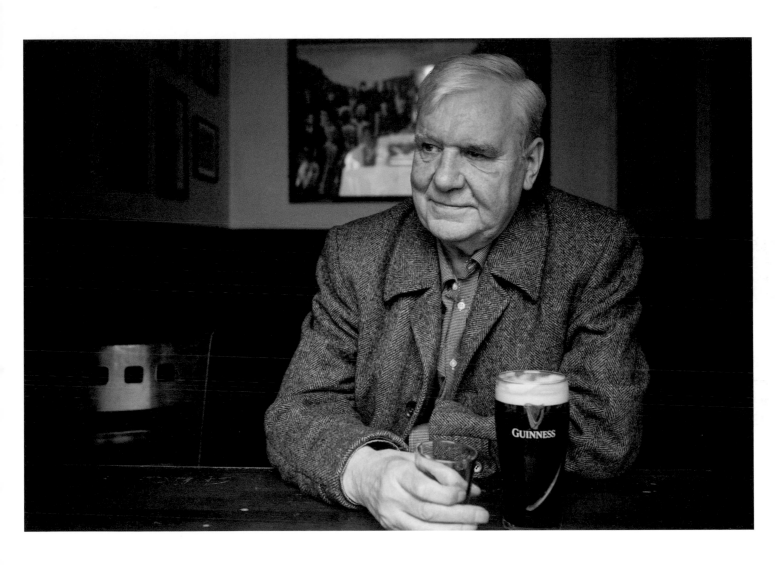

"I didn't expect anyone would remember anything we did. A lot of what I did was because I was mentally ill. I just didn't know when to stop."

With the meager income from Good Vibrations, Terri made recordings. One day, more out of empathy than interest, he offered The Undertones a contract. The band planned to split up if Terri would not partner with them. He dived with them into the studio, recorded the song "Teenage Kicks," and traveled to London with the single. In London, none of the record labels showed interest, so he left his promo single at the door of the popular BBC radio host John Peel. Disappointed, he went back to Belfast, but was utterly surprised when, that same evening, John Peel played "Teenage Kicks" and said: "Isn't that the most wonderful record you've ever heard in the world? In fact, I'm going to play it again." Unheard of in BBC history. Teenage Kicks became an anthem, the Northern Ireland punk song made it into the charts, and Terri became the "godfather of punk," a title he didn't like. "If I ever meet the journalist who gave me that title, I'll punch him in the face. Although I don't believe in violence much. Because I'm not a punk, never was a punk, never will be a punk ... but I might have a punk attitude."

Subsequently, a biographical drama was made about the life of Terri Hooley, and he appears in countless documentaries about his beloved Belfast. Terri remains stoic and even cynical: "I didn't expect anyone would remember anything we did. A lot of what I did was because I was mentally ill. I just didn't know when to stop."
As long as there is Guinness and, once in a while, a joint, it makes no difference to Terri. You don't switch anarchy on and off just like that.

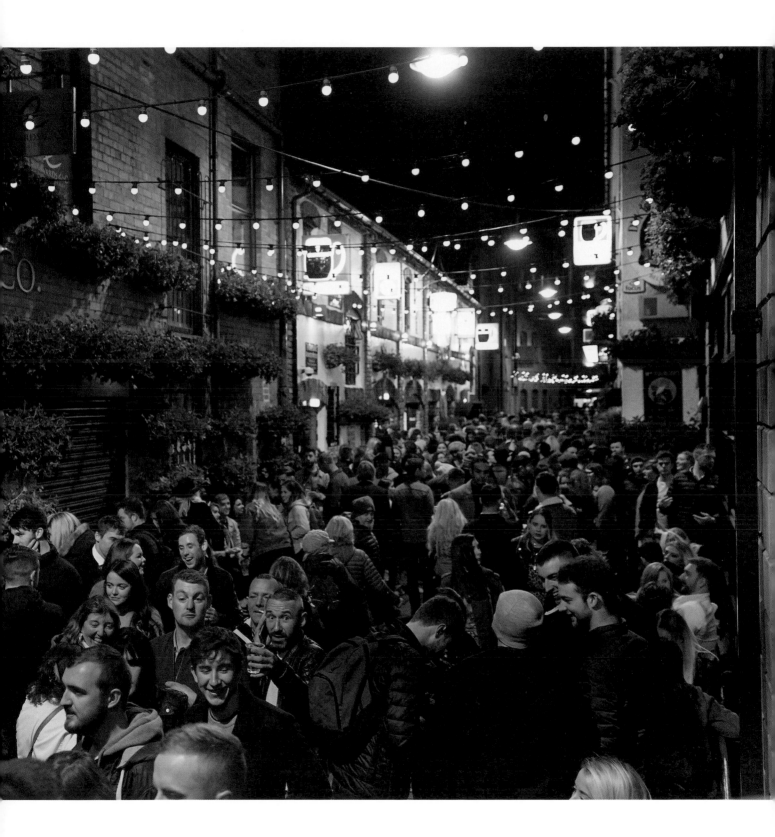

THERAPY?

It was 1989. The Troubles were still ongoing, but Andy Crains did not let himself get involved. He grew up in rural Ballyclare, 13 miles from Belfast. The Crain family were Protestants, but not radical. Andy's father lived with the fear that his son would become radicalized. To keep their children away from The Troubles, they moved away from Belfast, first to Antrim, near the city, but when the paramilitary took over there too, they moved to the country.

As a teenager, Andy regularly went to Belfast to buy records at Terri Hooley's Good Vibrations. "Good Vibrations was the place if you wanted to find good records. But the center was bombed on a regular base. So, I would say to my parents: 'I'm out to buy some records.' And they'd say: 'Be careful.' If I think about it now, letting your kid go to a city that's been bombed all the time ... We were desensitized."

In 1989, inspired by the punks, Andy decided to start a band. He found a drummer, Fyfe Ewing, and on the Catholic side a bass player named Michael McKeegan. They called their trio Therapy? (with a question mark). Although religion meant nothing to them, in Northern Ireland they had to watch their step. Michael grew up in the coastal city of Larne, north of Belfast. His parents sent him to one of the first mixed schools for Protestants and Catholics, so consequently, Michael received a very liberal education. Besides sometimes being called a "Fenian," a derogatory slur for Irish Catholics, he didn't encounter any bad experiences with Protestants. And yet, the situation in Northern Ireland determined his worldview: he had the idea that the entire world was like Belfast. Every day on TV he saw explosions, burning tanks and casualties. Music gave Michael an outlet from this violent context. When his horizons broadened, he discovered that the rest of Europe lived a different reality.

The band secretly rehearsed in an obscure rehearsal room in Rathcoole, a suburb of Belfast and an extremely loyalist neighborhood. Once, on the way to a rehearsal, Michael saw the letters K.A.I. on a wall. "I was quite naive, so I asked Andy: 'what does K.A.I mean?' He said: 'Kill All Irish.'" If people in the neighborhood had found out that Michael was Catholic, it would not have gone down well.

The band rapidly produced hits. In 1993 the breakthrough single "Screamager" got into the charts, and Therapy? went on a world tour. Their best-known number was their cover of the song "Diane", which reached the top ten in many European countries.

Andy and Michael, a Protestant and a Catholic who rarely talk about religion or The Troubles, have now been playing together for more than 30 years. The punk heritage from the 1970s immensely influenced the "grunge" generation. They click musically, and that's the only thing that matters.

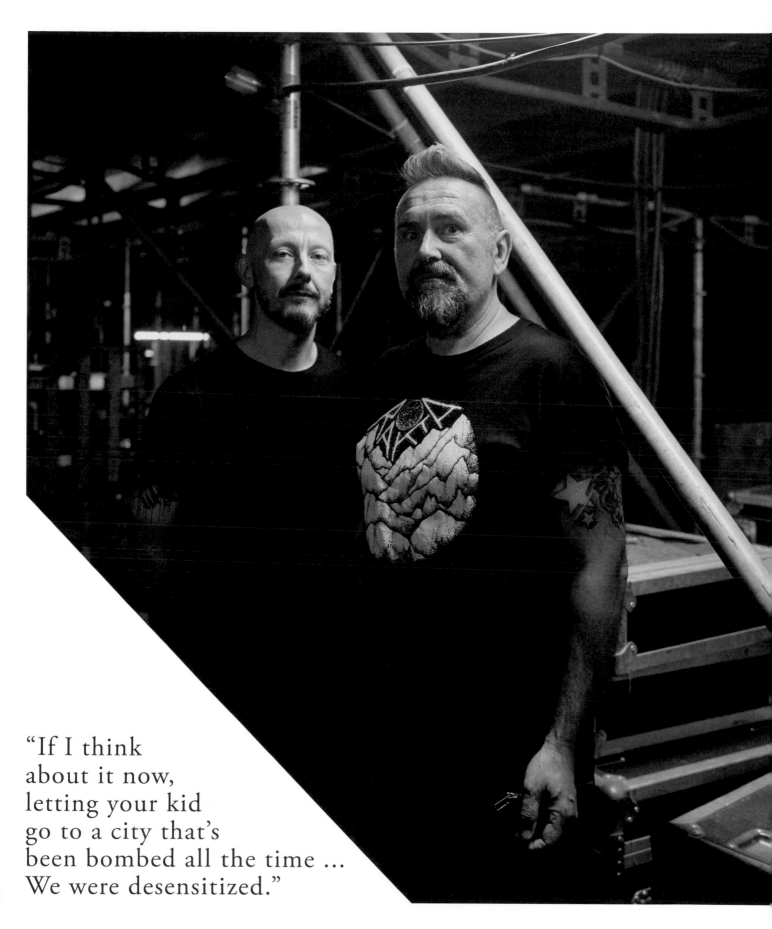

"If I think
about it now,
letting your kid
go to a city that's
been bombed all the time ...
We were desensitized."

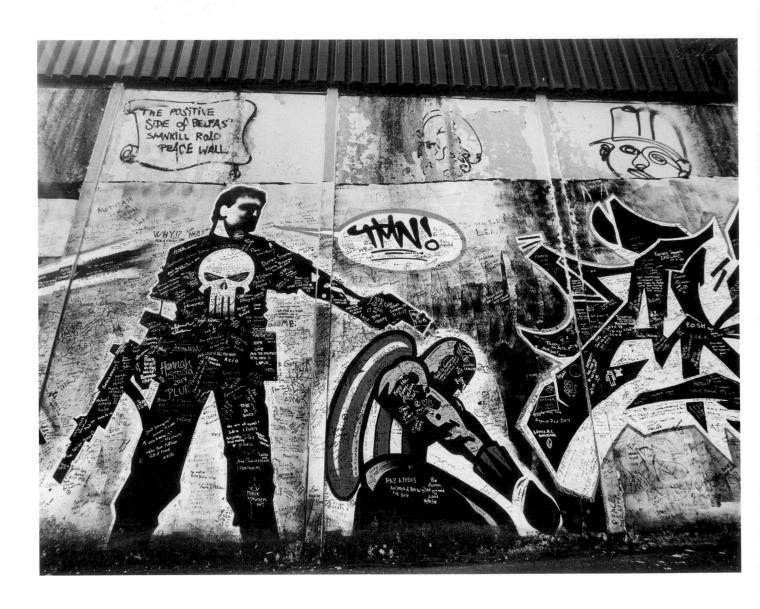

"Our choir represents
the growing unity of this city."

MARIE LACEY

Marie Lacey grew up in east Belfast. Her family was proof that brothers and sisters can go in very different directions because of environmental factors. Although her parents were fairly neutral, Marie's brother shifted towards stereotypical loyalist thinking: it is us against them. He joined one of the many Protestant marching bands, which represented the triumphant military character of Protestantism and British supremacy.

Marie's best girlfriend was shot down before her eyes at the age of 16, but she did not allow herself to be dragged in. She viewed her slain friend as a random victim in a world of "an eye for an eye and a tooth for a tooth."

Marie wanted to unite people. She was a singer, and from her perspective, a choir was the best way to unite people. In 2009, she established the Belfast Community Gospel Choir, the first and only multicultural choir in Northern Ireland. Not only were both Protestants and Catholics welcomed, but people of all color, religion and origin were able to audition. The only condition for joining the choir was to prove that you could sing. "We are the choir that rose out of the ashes. I had a real passion to create a choir that would represent the diversity of our city, the growing unity that is developing."

The choir got off to a flying start and became Marie's full-time occupation. They sing at events and on festivals in Protestant and Catholic churches. They even sang for the Queen during her visit to the Titanic Museum in Belfast. Marie considers the Belfast Community Gospel Choir a family and an example of the new era in Northern Ireland. Sounds good.

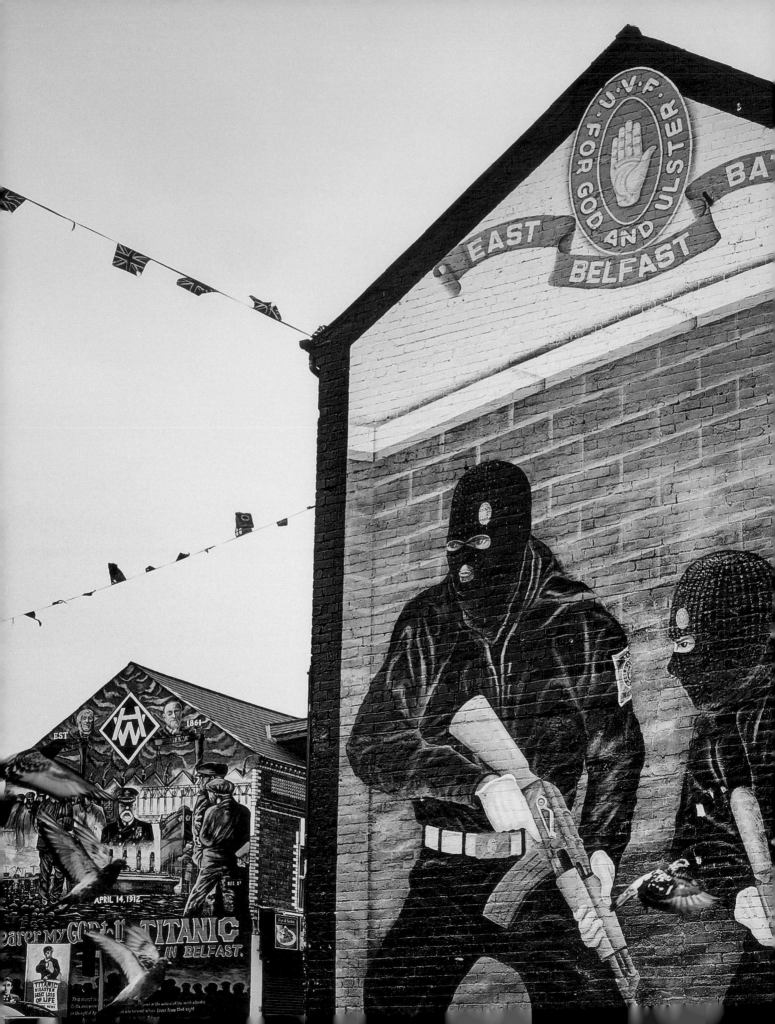

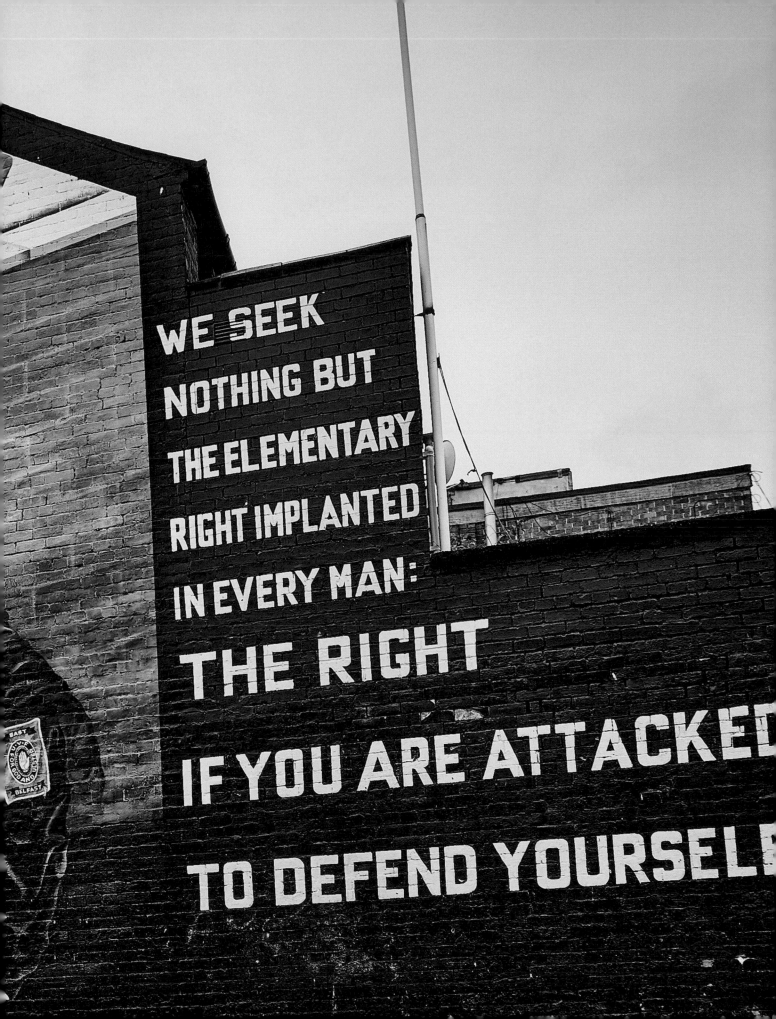

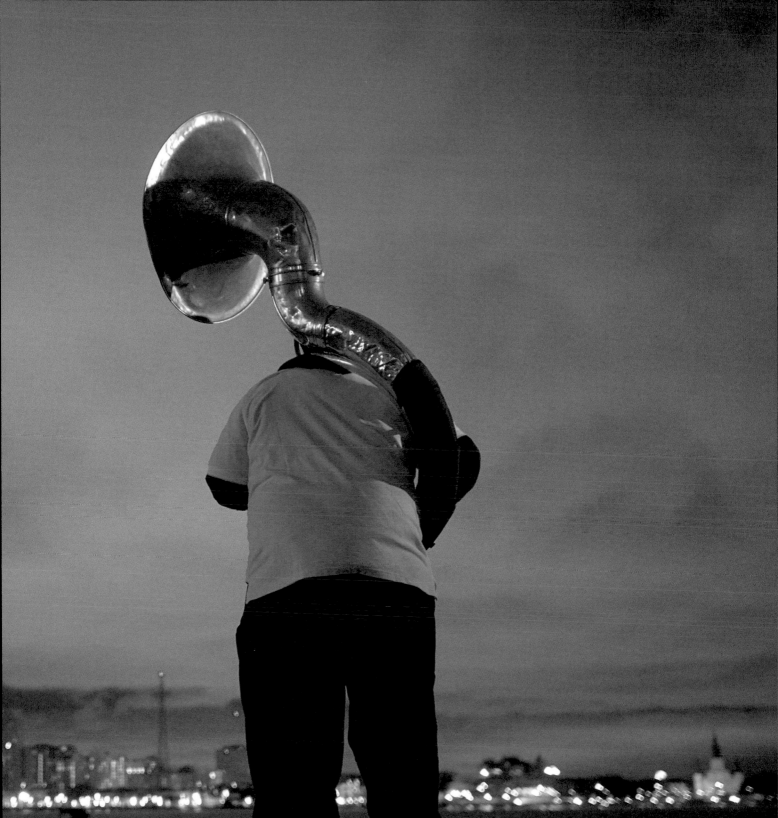

III. New Orleans

Deceit and lies are interwoven into the history of New Orleans. In 1717, Scottish economist John Law convinced the French monarchy to exploit its overseas colony of Louisiana. He did this by creating the notorious Mississippi Company, a state commerce company with a monopoly on trade. Law deluded the French into believing that within ten years he would populate Louisiana with six thousand white colonists and three thousand black slaves who would work in pearl farming and in gold and silver mining. Only there was no gold or silver in that territory and the few pearls found were worthless.

Unaware of this, the governor Jean-Baptiste Le Moyne de Bienville rushed to establish a settlement on the banks of the Mississippi River in 1718. He called it Nouvelle-Orléans, in honor of the French regent, the Duke of Orléans. It was actually madness to establish a settlement in the sweltering hot swamps teeming with alligators, snakes and mosquitoes.

Meanwhile, in France, John Law began a misleading campaign about the riches of Louisiana that lay there for the taking. He rapidly sold new shares of the Mississippi Company even before Nouvelle-Orléans was a town. Law was unable to convince colonists to start a new life in his swamp, so out of sheer necessity, a population was put together comprising of inmates, smugglers, vagabonds, reckless soldiers and outcasts from prominent families. Because of a lack of women, convicted Parisian prostitutes were given the choice of serving their sentence in jail or traveling on a one-way ticket to the new colony. With such an erratic bunch of people, lawlessness prevailed in Nouvelle-Orléans. The fortune hunters had little interest in working hard, so the Mississippi Company was forced to import many African slaves.

In 1731, John Law's bubble burst, causing a financial crisis, but the city of Nouvelle-Orléans was established. France abandoned its American colony and it was taken over by Spain. Two city fires burned down nearly all the wooden houses, so the Spaniards designed a new city plan, and the old center, the French Quarter, rose again with typical Spanish colonial houses. In 1800, Spain returned the territory of Louisiana to the French, who four years later sold it to the Americans because Napoleon needed money.

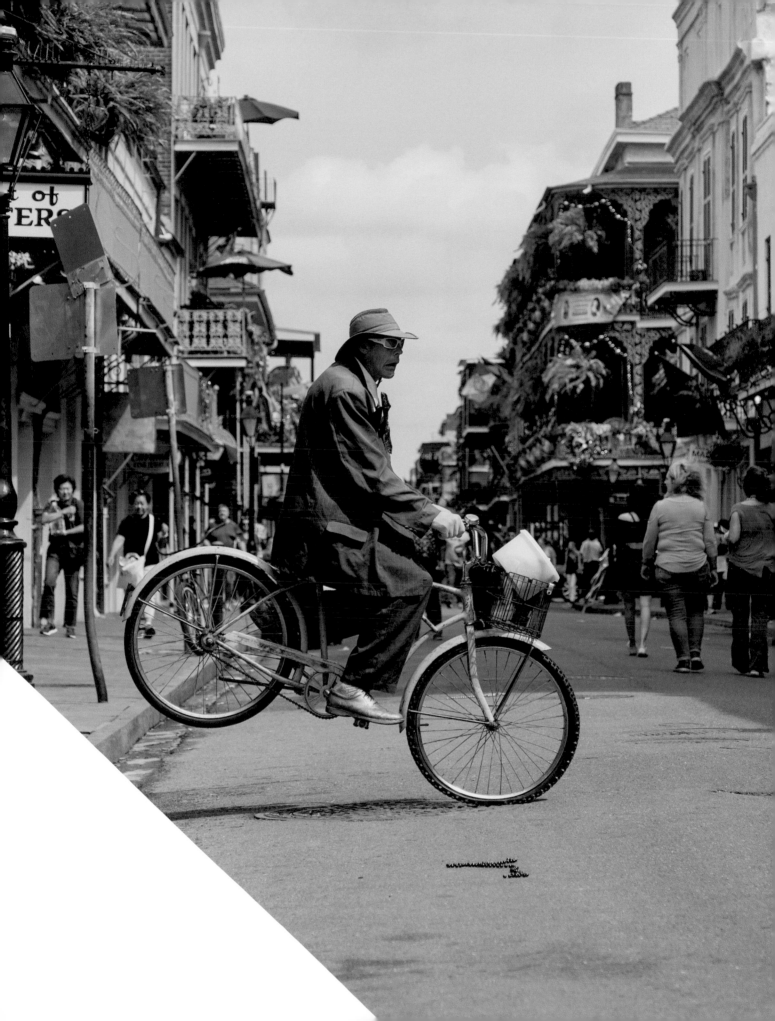

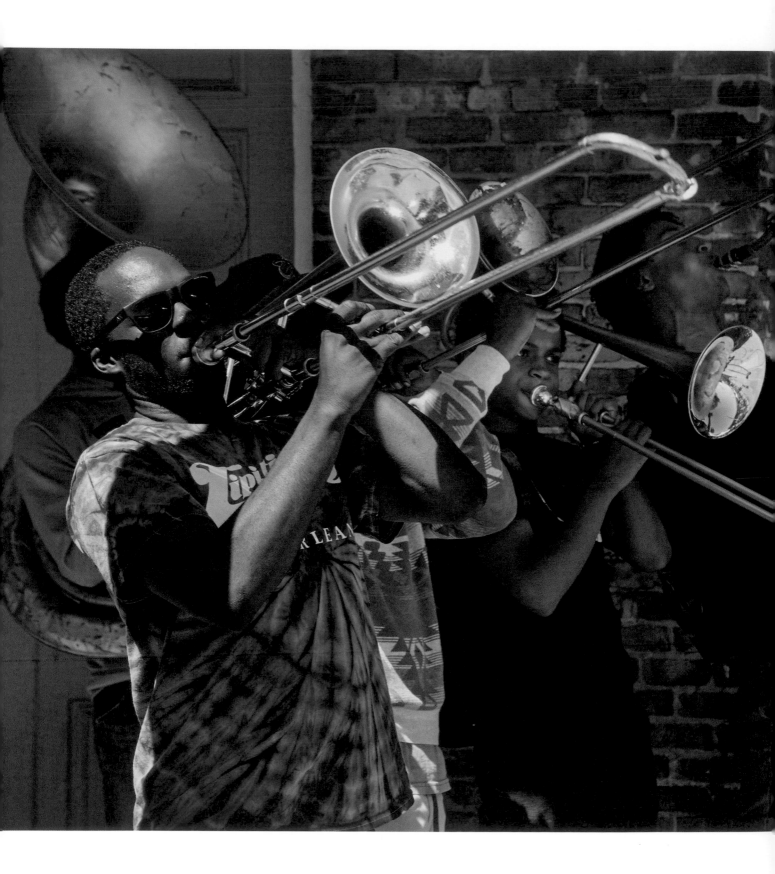

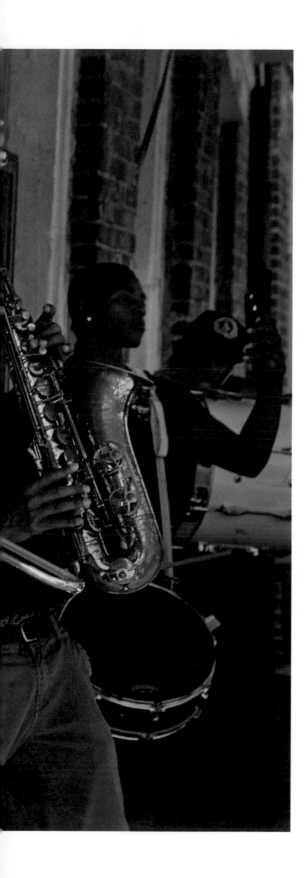

Thus, New Orleans became a melting pot of French- and Spanish-speaking Creoles, Anglo-Americans, slaves and free blacks. It was the biggest city in the southern United States, and it developed into the most important port for the slave trade. Under the American government, New Orleans became a gambling city with legal prostitution. The brothels in the former Storyville district offered jazz pioneers work, and the musicians quickly became a great attraction. Jazz spread worldwide from the brothels of New Orleans.

After the red-light district of Storyville was abolished, Bourbon Street took over the reputation as a sultry music street. New Orleans was nicknamed "The Big Easy," a reference to the carefree lives of the jazz musicians. However, New Orleans continued to suffer from heat, epidemics, crime, storms and hurricanes.

Residents of New Orleans had had their fair share of trouble during hurricane season, but in 2005, Hurricane Katrina hit particularly hard. Although Katrina was not the biggest hurricane in that season and just brushed past the city, its consequences were catastrophic. In more than 50 places, the hurricane breached levees that were supposed to protect the city, causing flooding in 80 percent of the city.

After the flood in 1965, a flood control act was passed to protect the city against new floods, but in 2005, the project was not yet completed. More than 100,000 houses were flooded and about 1,800 people died. More than 10 years after the disaster, the city still has not fully recovered, and some neighborhoods are still waiting to be rebuilt. In the French Quarter, however, everything looks the same as always and street musicians reign on the old colonial streets.

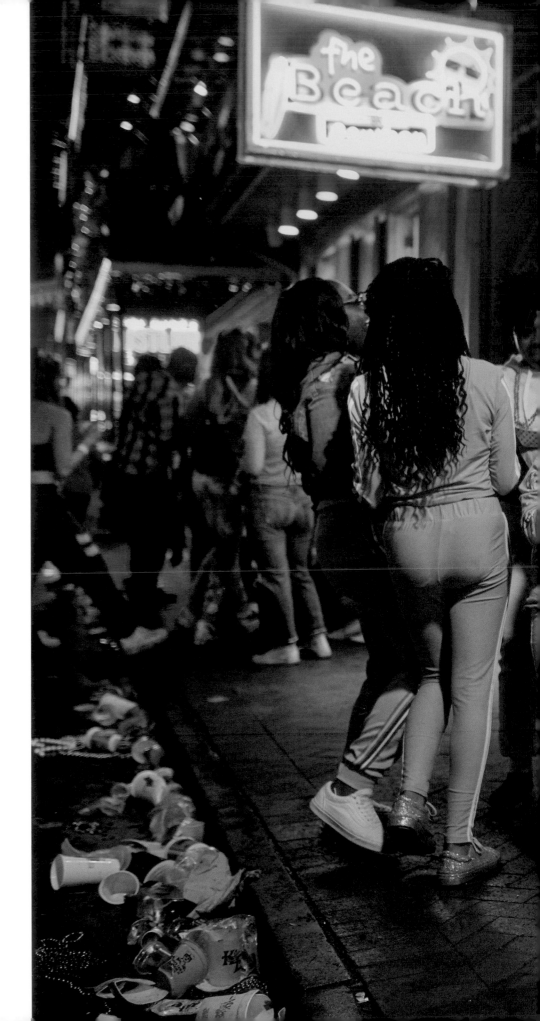

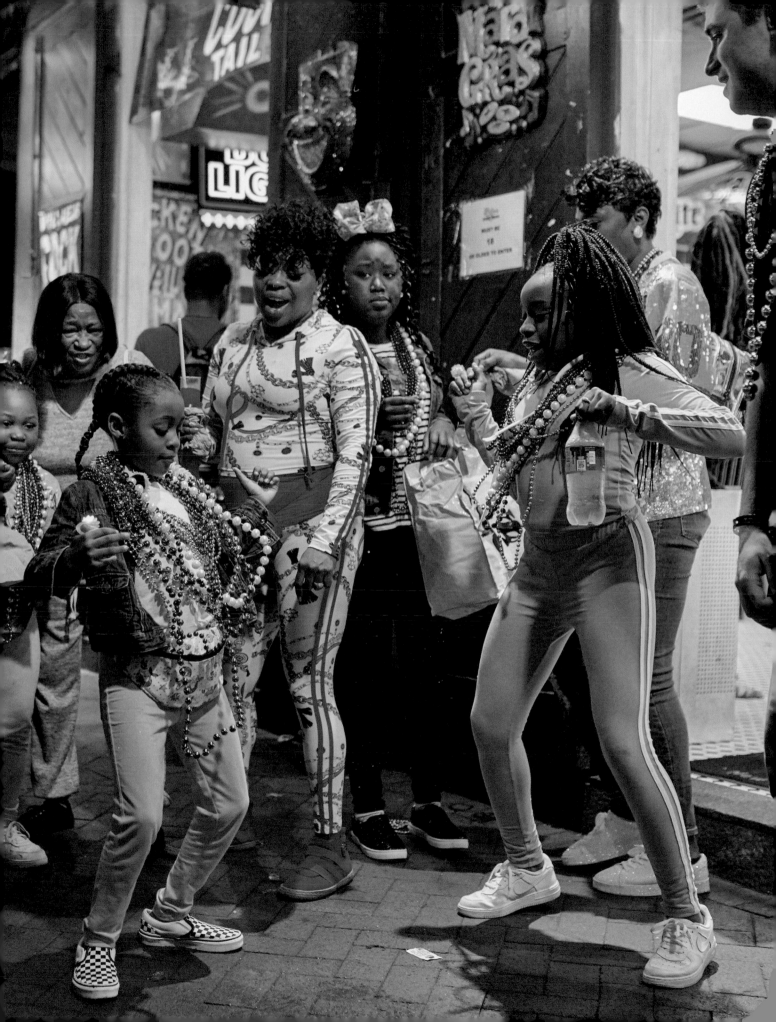

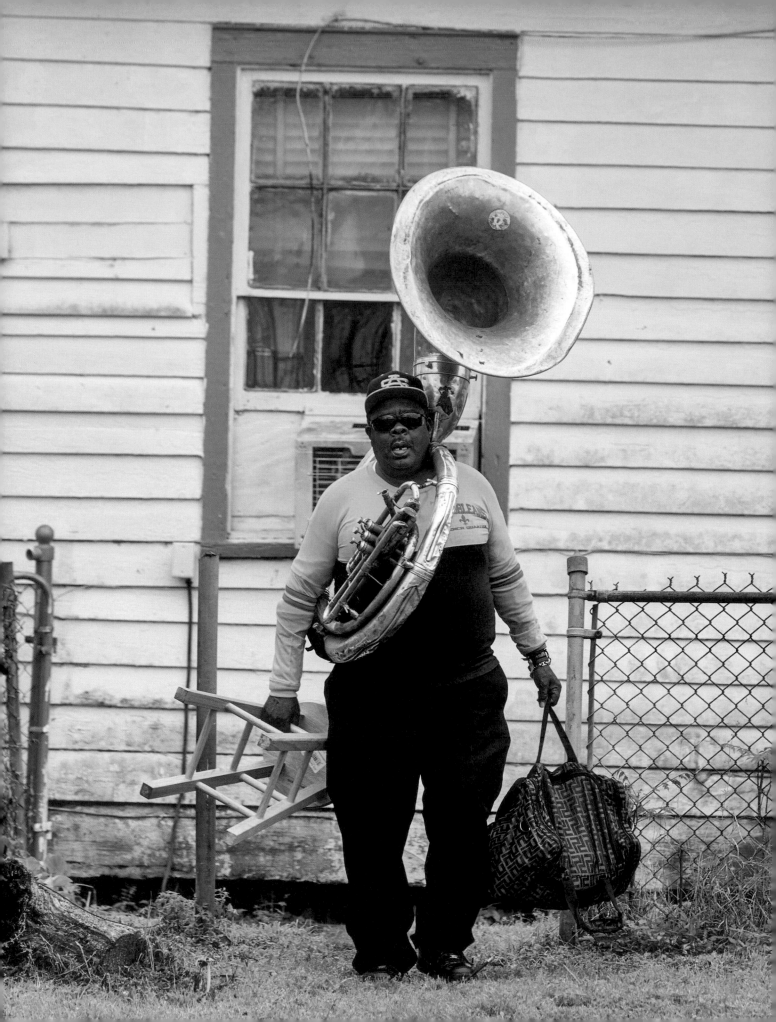

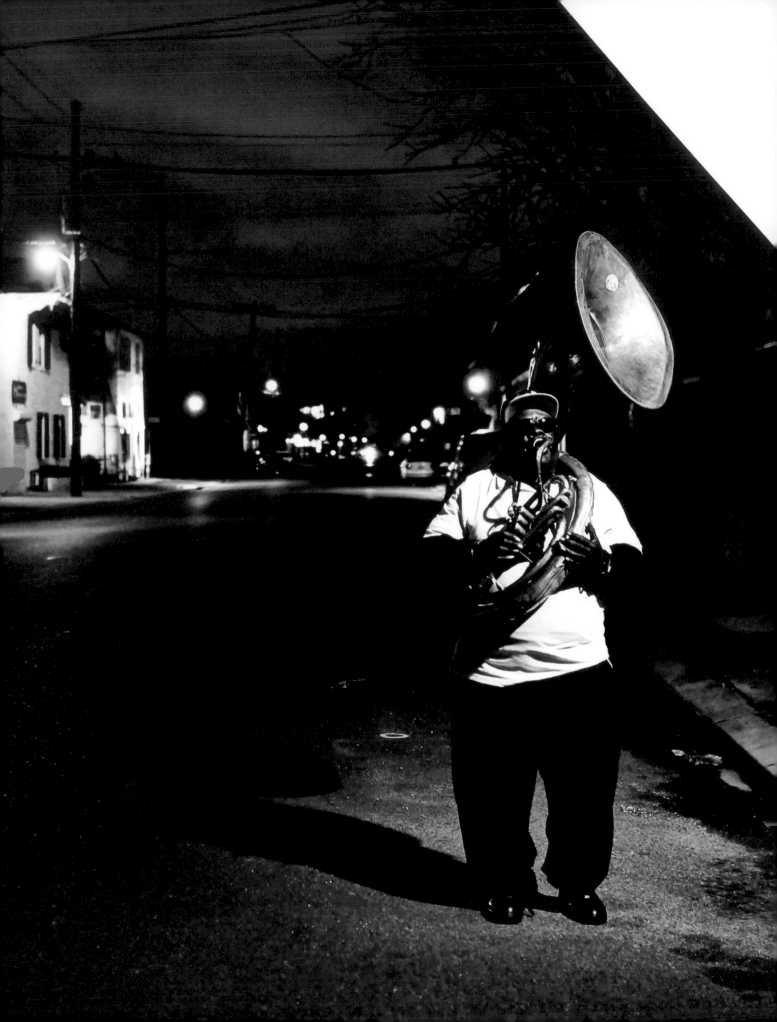

MARK "TUBA" SMITH

Mark Smith grew up in New Orleans. His mother was a gospel singer in a church choir and his father played the guitar.

At a local church, Mark witnessed his first jazz funeral, a funeral procession with a brass band. He noticed that the funeral procession consisted of a first line of musicians, funeral personnel, and family and friends of the deceased, as well as a second line of spectators who wanted to enjoy the music. Mark was fascinated by musicians who walked with enormous sousaphones, a type of tuba, around their necks; the instruments produced sounds that shook his body.

A brass band played daily on Jackson Square, in the center of the historic French Quarter. One of the band members was Anthony Lacen, a tuba veteran from the 1960s. Mark often went to listen to the band, and Anthony took him under his wing. The music veterans were very generous about sharing their knowledge. "They got it from someone themselves, they got to pass it on," says Mark.

Mark was barely seven when he first held a gigantic tuba around his small shoulders. But from the moment the metal touched his body, he was sold on the instrument.

In 1972, when Mark was 13, he began his career as a tuba player. He played in a popular brass band in New Orleans and toured the United States and Europe. Mark goes daily to Jackson Square and has become a fixture there. "It might be storming, snowing or shining, I'll be there. I treat it like a job." He is the best-known tuba street performer, and everyone calls him Tuba Man.

The life of a street musician has its downside. Mark got drawn into drugs, liquor and violence. He burned in rage and hated the world. Due to a number of incidents that he prefers to forget, Mark left the Ninth Ward, the neighborhood where he lived, and moved to the Algiers neighborhood, on the other side of the Mississippi. "It was self-destruction. I was hating everyone, and you sure can't play music hating people."

From Algiers, Mark walks one and a quarter miles each day with the tuba around his shoulders to the ferry that takes him across the Mississippi to the French Quarter. By now, that walking is more like waddling. "Like a penguin." On the way, he plays swampy bass tunes for the neighbors who leave for work or children going to school. Mark has become a well-known and loved figure in his neighborhood. "The people of the neighborhood, they are going crazy, they treat me like their king. The ladies next door call me their little celebrity."

That his neighbors consider him a celebrity is due to an iconic photo taken shortly after Hurricane Katrina.

On that fateful day, he was on his way home from church when the water level on the streets was still moderate. But, the moment he stepped into his house, an unending stream of water flowed in and Mark was stuck inside. When he was evacuated by boat he took only one possession with him: his tuba. He was taken to the Superdome, the biggest stadium in New Orleans, where he stood with the tuba around his shoulders, bewildered about the enormous devastation. A photographer snapped a picture and it became an iconic photo after Hurricane Katrina: a musician who left all his possessions behind during his escape from the rising waters, except for his instrument. "If I leave my tuba behind, I might as well jump into the water too. That instrument is my life."

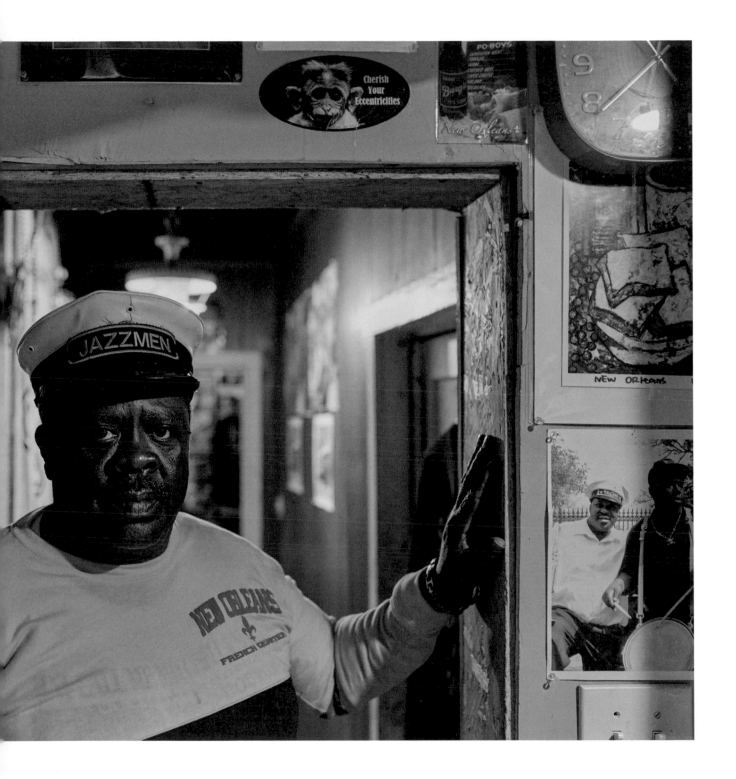

"If I can't touch your heart playing music, I tell
the people, you don't have to put money in the basket."

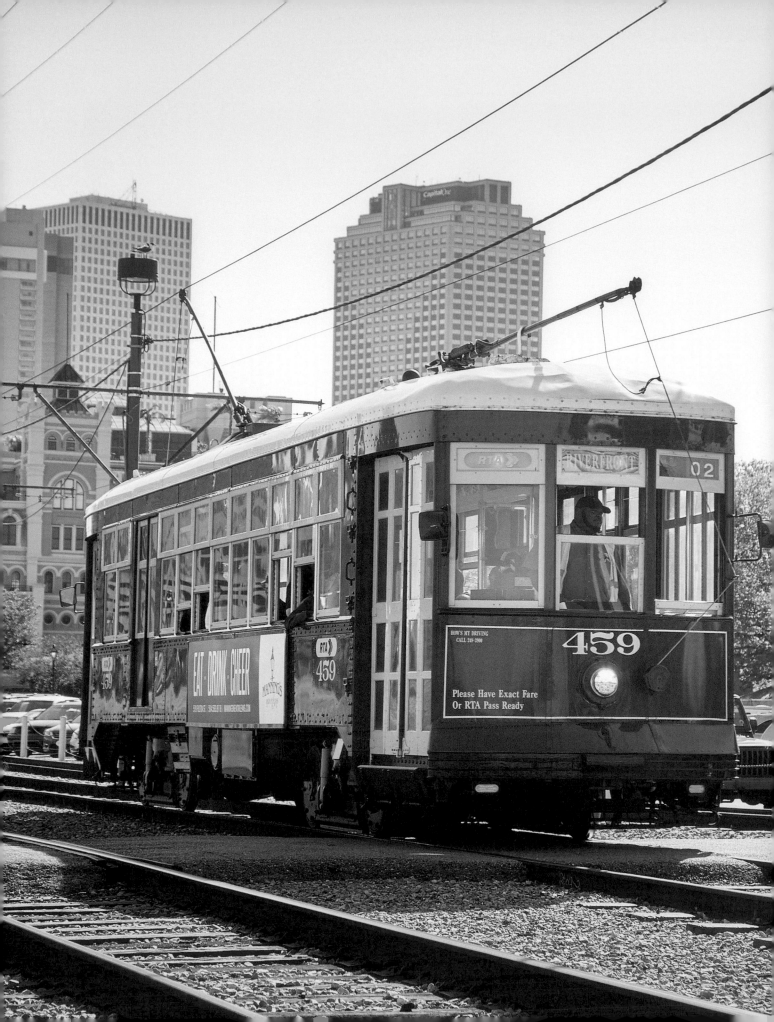

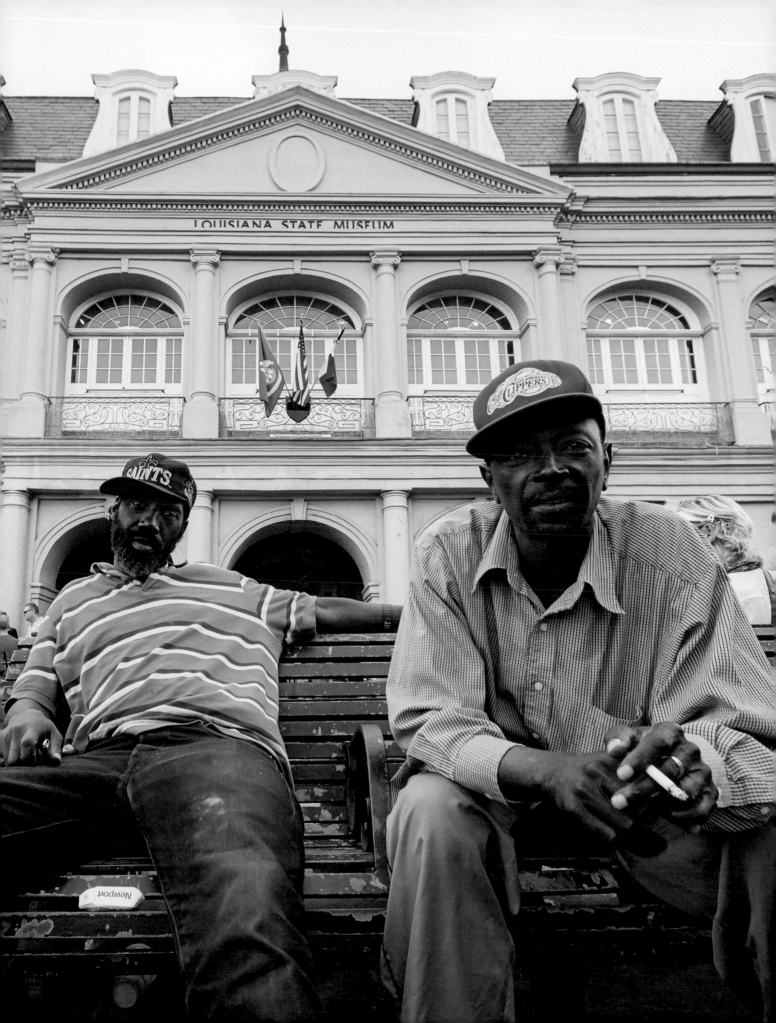

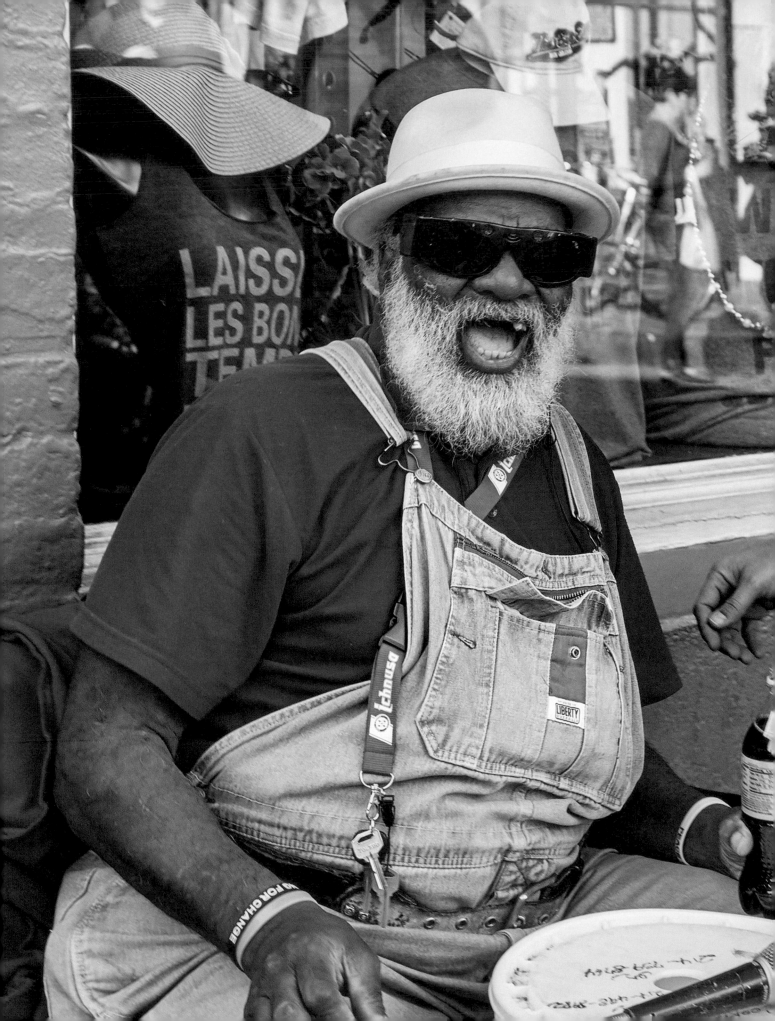

GRANDPA ELLIOTT SMALL

As a young fellow, Elliott Small quickly learned that the streets of the French Quarter were a goldmine. Tap dancing was a popular street act, and Elliott learned it by watching and imitating Fred Astaire on TV. He didn't have tap shoes, so he attached metal plates to the soles of his shoes. He discovered that his body was full of rhythm, and then one day, a talent scout from New York noticed him. He proposed that Elliot go to New York and launch a career on Broadway. So, Elliott moved to the Bronx with his mother.

Elliott's first performance on Broadway was a success, but fate struck unexpectedly. His mother had a new boyfriend who liked to drive fast, and one day, when they were out on a date, they smashed into a tree, and both died instantly. When the news got around the apartment building, neighbors used the tragedy to loot the apartment empty instead of assisting the young and helpless Elliott. Elliott was left to his own devices until his grandmother brought him back to New Orleans to take charge of his upbringing.

Elliott discovered that he also had a talent for singing and learned to play the harmonica. At the age of 14, life dealt him another blow. His vision had deteriorated as a result of glaucoma, and he eventually became blind in one eye, while the other eye slowly worsened. Elliott used eye drops to reduce the pressure on his eyeball and to avoid becoming entirely blind.

Elliott began writing songs in the 1970s. He recorded a number of singles, yet success remained out of reach. In his own words, he wrote a few powerful melodies, which colleague musicians stole from him without sharing in the profits. "I should have been a millionaire ten times over. Or maybe more."

In New Orleans, a street musician with a strong act can earn a lot of money. Elliott did this by forming a duo with guitarist Stoney B. Since he was going blind, he played the role of a blind man. Elliott sang alongside Stoney using a lot of movement and expression. Their repertoire consisted of blues and New Orleans traditional music.

Stoney called him Grandpa, and he adopted this role as his musical identity, becoming known by many as Grandpa Elliott. During that period, he began wearing the same outfit: blue dungarees and a red shirt. His white beard, sunglasses and hat completed the image. Their act was a great hit, and on any given day, they easily collected several hundred dollars in tips. But in his own words, Grandpa Elliott is too generous, and he gave money to whoever needed it.

After they had played together for 12 years, Stoney B decided to start a new life in California. Grandpa Elliott lost his partner, and the golden times were over. He continues to play, solo, and makes quite a bit of money with his rough yet warm blues voice and perfectly controlled timbre.

Hurricane Katrina made a big dent in Elliot's profits. He was forced to move to Houston and his income shrank. But he eventually returned to the city of his heart. The French Quarter provided him with comfort and healing. Whenever he felt bad, he would go and sit on his fixed corner on Royal Street, which runs parallel to Bourbon Street but has a totally different atmosphere.

Bourbon Street is debauched and extravagant, on the edge of vulgarity, with women flashing their breasts for cheap necklaces tossed at them from balconies. One sometimes encounters groups of fanatic believers who loudly try to convert the godless passersby. They carry signs saying "Jesus saves from Hell," while six feet away is a topless woman with a sign advertising nipple glitter.

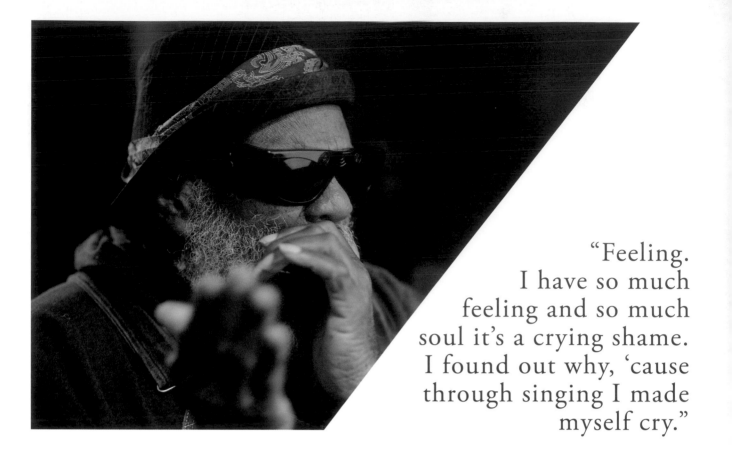

"Feeling.
I have so much
feeling and so much
soul it's a crying shame.
I found out why, 'cause
through singing I made
myself cry."

Bourbon Street was once a street of fantastic jazz, but today the street mostly has average cover bands, fluorescent sweet drinks and drag queens. The brothels are still there.

Royal Street is the opposite of Bourbon Street. It reflects class: it has dozens of antique dealers and art galleries and countless street musicians. Grandpa Elliott has become an inseparable part of the Royal Street scene. He sits each day against the salmon-colored façade of a souvenir store on the corner of Royal and Toulouse. It was there that he was spotted by Mark Johnson, co-founder of the Playing for Change Project. Mark recorded Elliott in a performance of street musicians from all over the world playing Ben E. King's song "Stand By Me." Elliott played the chief role in this video. With the advent of YouTube, the video went viral, and all of America discovered Grandpa Elliott.

Elliott was invited to various late-night talk shows and went on a world tour. By then, their version of "Stand By Me" had gotten over 130 million views.

Just before one of his plane trips, Elliott's eye drops were taken away by the security staff. During takeoff, Grandpa felt that his eye could not take the air pressure, and he lost the last bit of vision that he still had. From that moment, he was blind for the rest of his life and wore heavy sunglasses.

The Internet hype quickly wore off, and when his new album flopped, he again landed on the streets of New Orleans. People from all corners of the world came to New Orleans to see Grandpa perform, but his handicap made it more and more difficult to stay on the street. Other musicians would sit in front of him and drown him out with their amplifiers. Grandpa Elliott got no more opportunities, and his financial situation became more and more difficult.

Fortunately, despite his age and many setbacks, there is still the healing power of music. "I've been having bad luck all my life. I can be very depressed, but all that's gone when I go to the French Quarter. I don't need no medicine, the Quarter is my medicine."

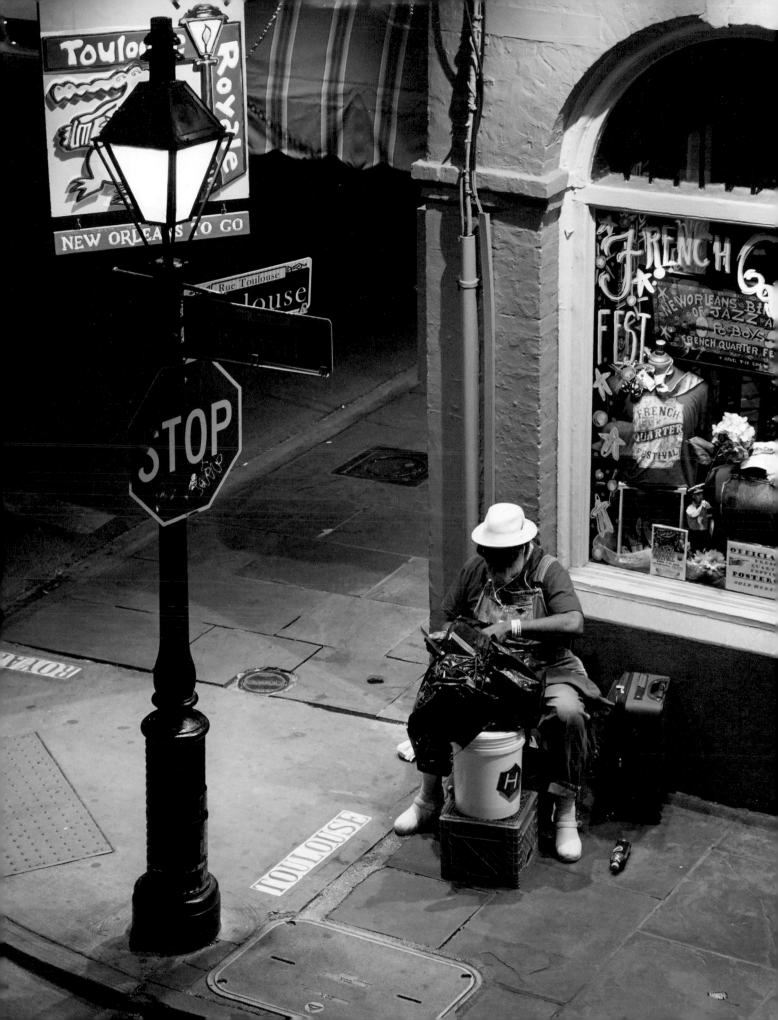

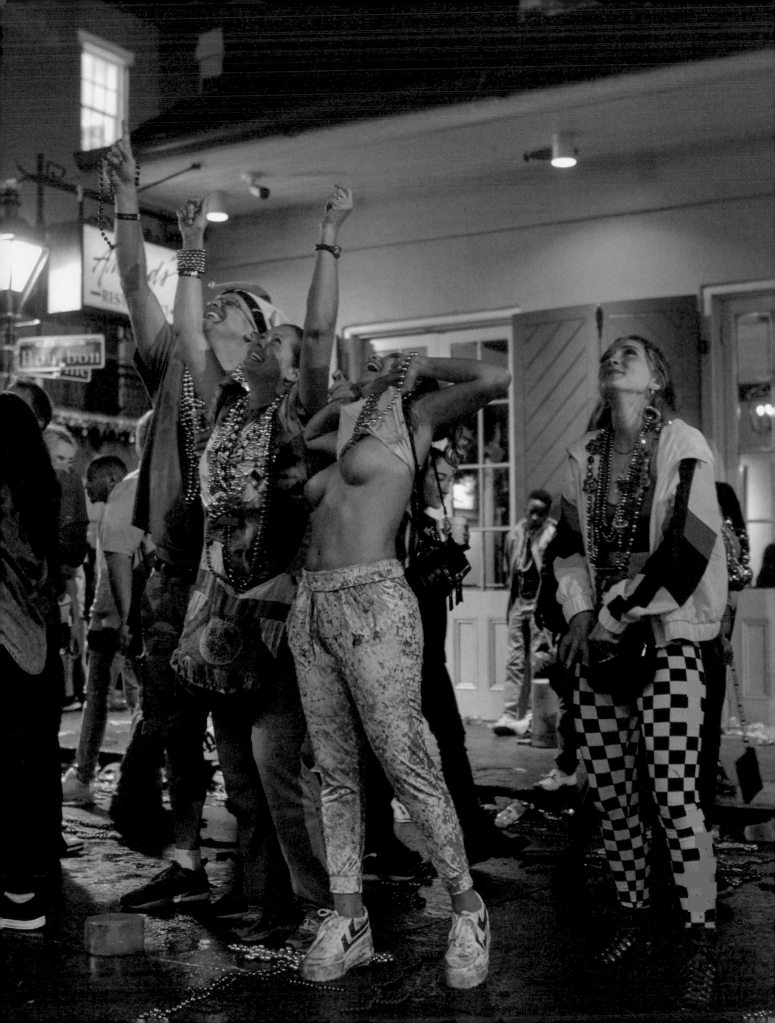

"When we put on the suits, we appear to be Indian because of our dress, but behind the suit and the mask is Africa."

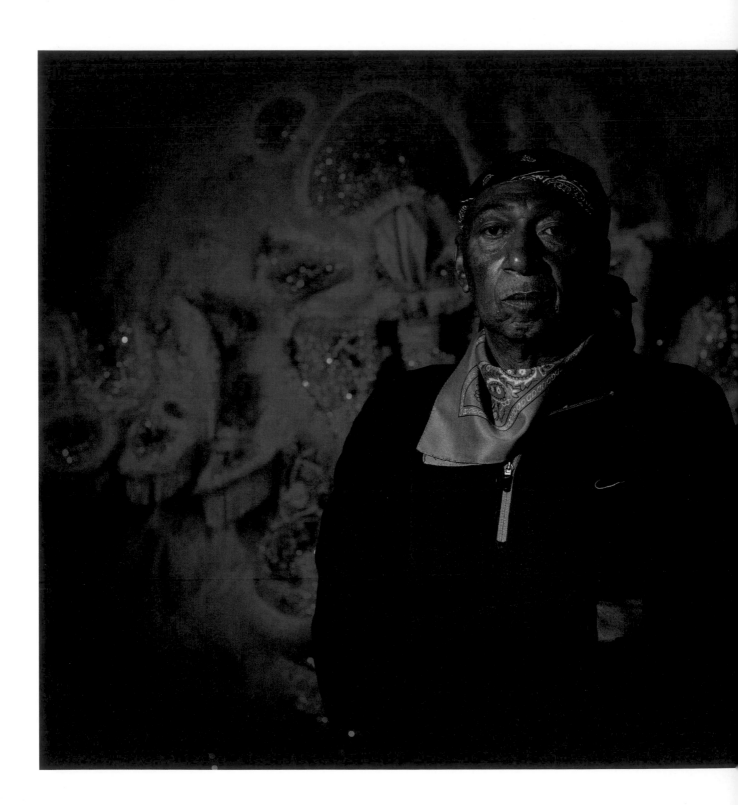

BIG CHIEF HOWARD MILLER

Big Chief Howard Miller is the tribal chief of the Creole Wild West, the oldest Mardi Gras Indian tribe in New Orleans. Mardi Gras Indians are not simply carnival groups; they are tribes that originated from escaped black slaves that found shelter among Indians and made a unique pact with them.

When the Europeans colonized the New Orleans area, they drove the Indians to the swamps. New Orleans became the biggest port for slave trade in the US, and slave owners forbade any reference to Africa: language, African names, religions, even the Congo drums.

Many slaves managed to escape and were taken in by Indian tribes that were considered pariahs at the time. The slaves discovered that they actually had much in common with the Indians. In both cultures, it was customary to paint faces, adorn hair with feathers, live in tents and hunt with bows and arrows. Each culture had medicine men. Unlike the slave owners, who tried to deny the blacks their cultural identity, the Indians respected their religious and cultural practices in the camps.

Change came only when the colonialists introduced the carnival celebration to the New World and everyone could wear the costume they wanted. The African slaves saw their chance to practice their rituals and traditions on the streets of New Orleans while being dressed up in Indian costumes. "Of course we were there long before Mardi Gras, but it gave us a date, an outlet to practice our own culture," says Chief Howard.

The Mardi Gras Indians prepared the carnival celebration in utmost secrecy, even well into the twentieth century, because expressions of African culture were forbidden. The Mardi Gras Indians worked an entire year on their colorful costumes, some weighing up to 100 pounds. It was sheer drudgery and an expensive venture. As tribal chief, Chief Howard had the biggest and most impressive costume. "The costumes are very expensive, but I won't talk about the costs. People will think that I'm crazy." Every year, the expensive costumes are reused to make outfits for the younger members of the tribe.

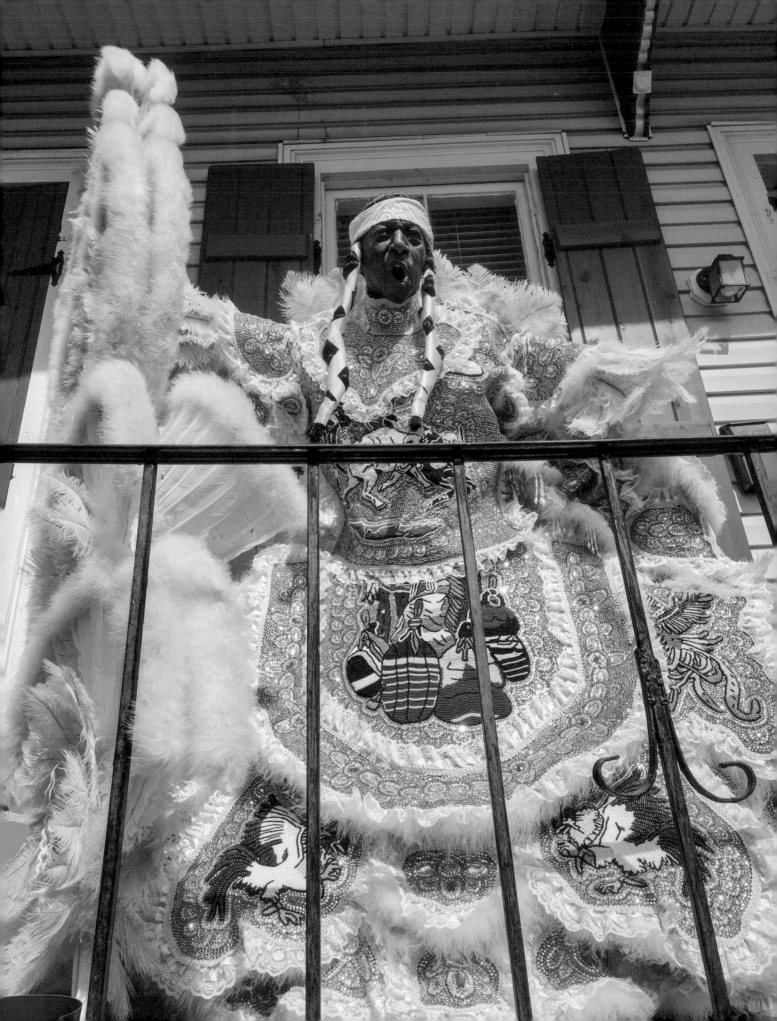

Howard has mixed blood. He is both a descendant of African slaves and Cherokee Indians. As a kid, he would watch the Mardi Gras Indians parade, and that left a lasting impression on him.

He decided to follow them and discovered where their clubhouse was located. Every day, he returned to the fence of their front yard. One time, he even managed to climb onto their porch where he silently peeked through the window. He saw feathers, beads and men sewing costumes. One day, when it was pouring with rain, Howard stood peering through the window, as always. The tribal chief noticed him and asked: "Is that boy still there? Let him in."

Howard was allowed to enter the mystical place for the first time. "Kiddo, you want to make a costume, don't you?" Howard nodded. "Can you sew?" Howard shook his head. "OK, come back tomorrow and we will teach you how to sew."

That's how Howard Miller was admitted to the Creole Wild West. When he was still a teenager, his tribal chief was murdered. A few years later, his successor shot someone dead and landed in jail. So in 1972, eighteen-year old Howard Miller was crowned the youngest tribal chief in the history of the Creole Wild West. As Big Chief, he has immense responsibility in the community. People look up to him, and he fulfils the role of a mayor.

Big Chief Howard focuses a great deal on children. He wants to educate them as much as possible, and he teaches them costume-making. "We have these kids, some of them coming from broken homes. This is a way to give them something that's positive. And it's more likely, if you are educated, we don't have to worry 'bout you knocking some old lady down and taking her purse. Because you'll be equipped."

Strict, but fair — this is the motto of Big Chief Howard, and the neighborhood has endless respect for him. "There are times they're looking at me as a mean old bastard, then there are times they say: 'I love you, Chief.'"

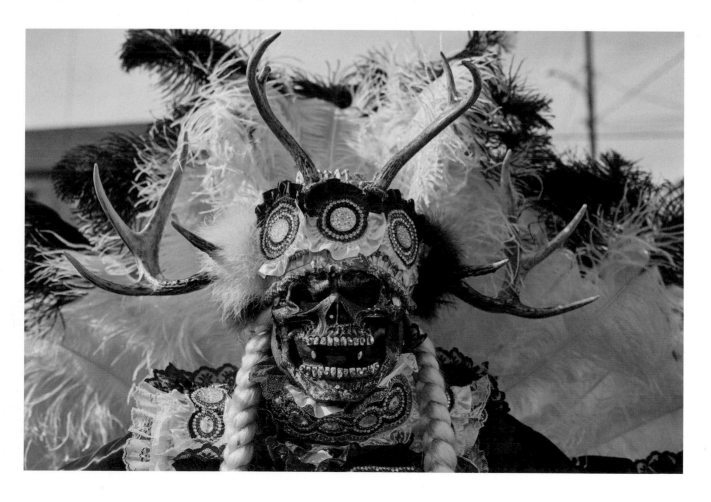

IV. Kigali

Kigali, the capital of Rwanda, is situated in the center of the country, surrounded by thousands of green hills. The Pygmies of the Twa tribe were the earliest inhabitants of this region. Over the course of centuries, the Hutu and Tutsi tribes moved into the region.

The Tutsis became the rulers of the kingdom, with a Mwami as the chief. The symbol of his power was the Kalinga, a large drum that was sprinkled with the blood of bulls and decorated with the genitals of enemies.

The drums from this region produce rhythms that are different from the typical Western rhythms that mainly follow the beat, the rhythmic pulse in a piece of music. In Africa, the rhythm is manipulated in such a way that it goes against the beat, producing a stronger sense of musical movement. At the end of the nineteenth century, these backbeats and polyrhythms played an important role in the development of new Western genres, such as jazz and blues.

At the end of the nineteenth century, the Germans established a presence in the region and the colonists considered the Tutsi minority — who occupied the majority of power positions — the superior tribe. In 1907, the German doctor Richard Kandt founded the city of Kigali. At the end of World War I, Belgium became the ruler of the region, which became known as Ruanda-Urundi. The Belgian colonists continued to stress the racial differences.

The size and shape of the nose was a criterion for differentiating between Tutsis and Hutus. The Tutsis had smaller, more European noses, which, to the colonists, indicated superiority. Even the circumference of the skull was measured to determine the size of the brain.

Since much was left to guesswork, the colonists introduced a controversial rule: If you have less than ten head of cattle, you are a Hutu. If you have more, you are a Tutsi. Ethnic origin was stated on the individuals' identity cards. Tutsis received economic and social advantages.

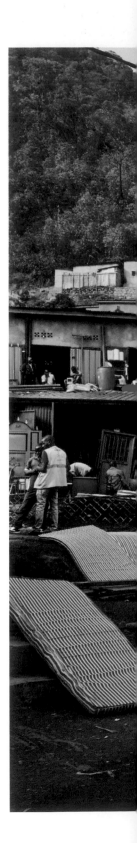

The grievances among the Hutus increased during the 1950s, and they developed into feelings of hatred. The pressure on Belgium to leave the colony increased, and in 1962, Ruanda-Urundi was split into two countries: Rwanda and Burundi.

In Rwanda, the Hutu majority seized power. The ethnic identity cards were still valid, and discriminatory quotas were applied against Tutsis in schools, universities and public jobs. Tutsi political parties were dissolved and their members executed. Tutsis were called "inyenzi," a derogatory term meaning "cockroach." In that climate, more than 700,000 Tutsis fled from their country between 1959 and 1973.

Rebel forces consisting of Tutsi refugees and their children were formed in the border regions of the neighboring countries. Paul Kagame was such a refugee. He grew up in a Ugandan refugee camp, but quickly climbed the ranks in the RPF (Rwandan Patriotic Front), a rebel army of Tutsis that hid in the Virunga highlands. At the beginning of the 1990s, plans were made in those mountains to invade Rwanda. Around 2,000 RPF rebels began a guerrilla war and occasionally managed to capture a small border area, but were driven back every time.

Seventeen years of power began to wear down the regime of the Rwandan Hutu president, Juvénal Habyarimana, who ruled from 1973 until 1994. Human rights continued to be violated, especially against the Tutsi minority. Schools highlighted the physiognomic differences between Tutsis and Hutus. With the poison of indoctrination oozing deeper and deeper into society, there were regular waves of murder. This was no coincidence. The "Hutu Ten Commandments" spread anti-Tutsi propaganda and racial bias that included a ban on interracial marriage. The Rwandan army distributed machetes to the

population and trained Hutu youngsters to become members of a dangerous militia, the Interahamwe. Radio fulfilled a sad role in the propaganda campaign. In 1993, a new radio station was established, RTLMC (Radio Télévision Libre des Milles Collines). It broadcasted racist messages, obscene jokes and hate songs.

In August 1993, peace talks between the RPF and the Rwandan government resulted in the Arusha Accords: the RPF was integrated into the Rwandan army, refugees were allowed to return home and the UN's Blue Helmets were deployed to maintain the peace. All good intentions came to naught, and the signs of genocide were ignored by the world.

On April 6, 1994, the Rwandan president Habyarimana and his counterpart from Burundi, Ntaryamira, were assassinated when their plane was shot down just before landing in Kigali. The perpetrators were never found, but this act of terror pulled the pin from the grenade, which ignited in the form of genocide. Radio Télévision Libre des Milles Collines called for a massacre. One hour after the attack, the first shots resounded in Kigali. Not only Tutsis, but also moderate Hutus were targets. Whoever did not actively take part in the massacre was killed. Women were beaten, humiliated, raped and killed, often in front of their families. Children had to watch their parents being tortured and killed. Elders, the pride of Rwandan society, had their heads bashed with machetes. Neighbors attacked each other, friends became enemies, and families betrayed each other.

The massacre went on for a hundred days. One million people were killed: ten thousand per day, four hundred per hour, seven per minute.

The genocide finally stopped when the RPF of Paul Kagame, reinforced with additional troops, overthrew the Hutu regime. Kagame became first vice president, and from 2000, president of Rwanda. He has been re-elected repeatedly, getting more than 90% of the vote. Under Kagame, there is no place for hate, but also no place for a free press or opposition. Rwanda still is an authoritarian state, but it can begin the long road to reconciliation.

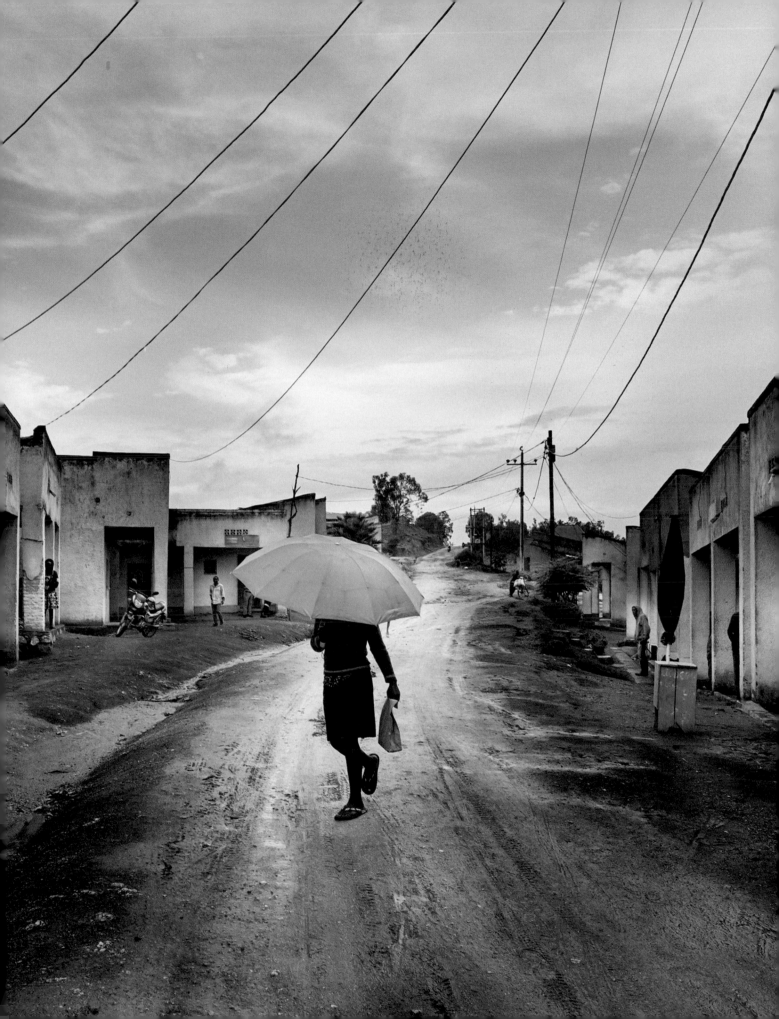

MUSEKEWEYA

Hate radio played the role of the devil in the run-up to the genocide. Radio Télévision Libre des Milles Collines called on Hutus to kill their Tutsi brothers and sisters. The hate messages were often explicitly gruesome. A fragment from a broadcast: "Join us to celebrate, friends! The cockroaches are being exterminated. If we exterminate the cockroaches once and for all, no one in the world will come and judge us."

Not only the language, but also the music injected the mind with murderous poison. One of the most well known convicted war criminals was a singer. In the 1990s, the popularity of Simon Bikindi in Rwanda could be compared to Michael Jackson's. His songs were played endlessly on Radio Milles Collines. In the song Nanga Abahutu (I Hate Hutus) he condemns moderate Hutus; other songs are cryptic. The fact that a musician has the dubious honor of being one of the most well-known convicts of genocide testifies to how the power of music can be misused.

"As a result of brainwashing, we did many ugly things. We thought it was our duty to kill Tutsis." says Joel Mugabowindekwe, a Hutu who participated in the genocide.

Nowadays, radio remains an important source of information in Rwanda and its many outlying villages. Despite the fact that radio is partly accountable for the immense damage caused, this medium nevertheless still has immense credibility.

In 2004, ten years after the genocide, the NGO Radio La Benevolencija wanted to dispel the negative undertone of radio in Rwanda, and produced a radio soap opera called Musekeweya (New Morning).

Musekeweya is a story about two fictitious villages, Bumanzi and Muhumuro. For generations they have lived alongside each other in peace, but conflicts between them arise when there is a shortage of fertile land. Moderate and radical villagers directly oppose each other. The tension increases further due to ethnic differences, which are not specified in the soap opera. However, the analogy to the Rwandan genocide is unmistakable, and Rwandans cannot fail to recognize themselves in the characters. One character is forgiving, another is neutral and a third pours oil on the fire.

The soap opera is based on true stories that occurred in many Rwandan villages. In 1994, Hutus from the Giheta village crossed the mountain to Ruseke, inhabited by Tutsis. They inflicted a bloodbath with their machetes.

Musekeweya draws the Rwandan people into a process of reflection: What role have they played during and after the genocide? Which character do they most identify with? The soap opera aims to show people the path to reconciliation and teaches the villagers how to deal with their sorrow, how to start talking to one another again, how to forgive each other, to put their anger aside and to start living together again.

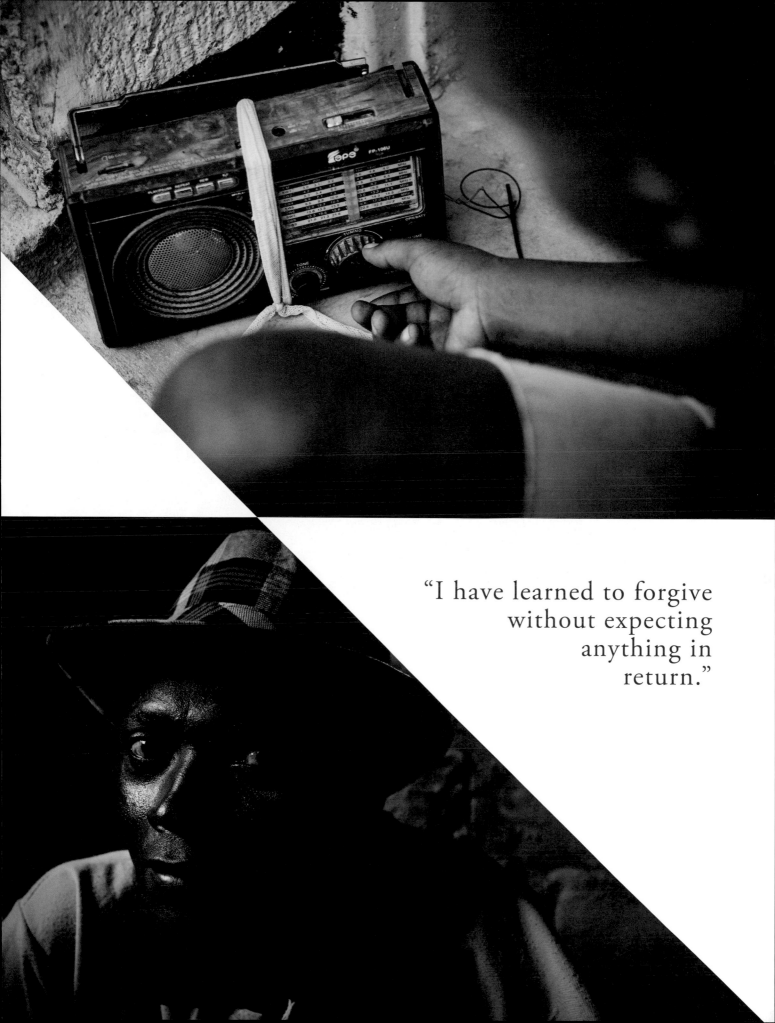

"I have learned to forgive without expecting anything in return."

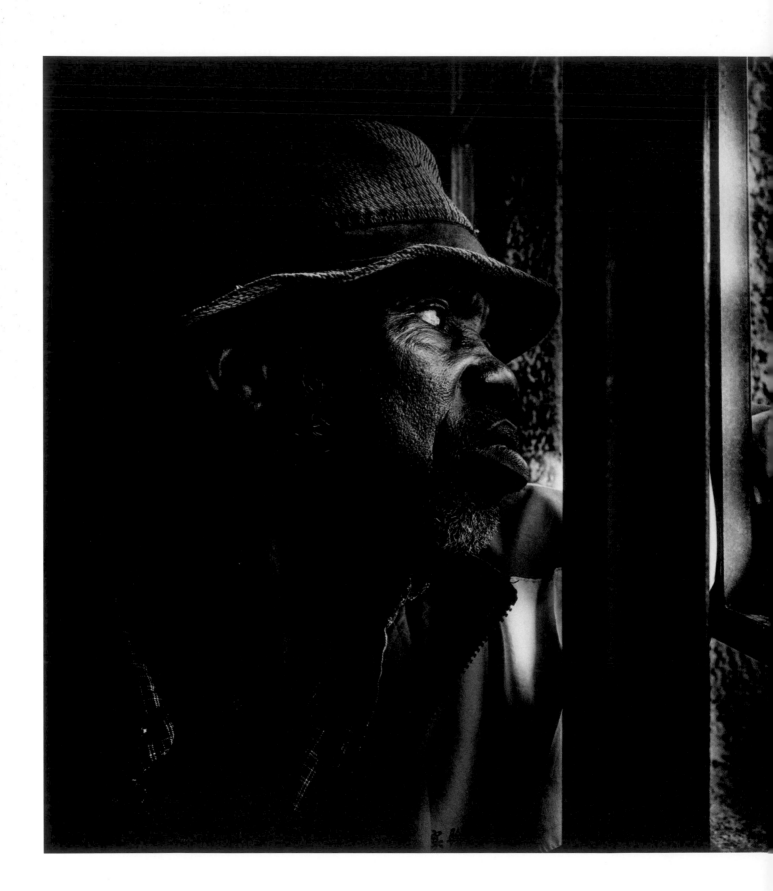

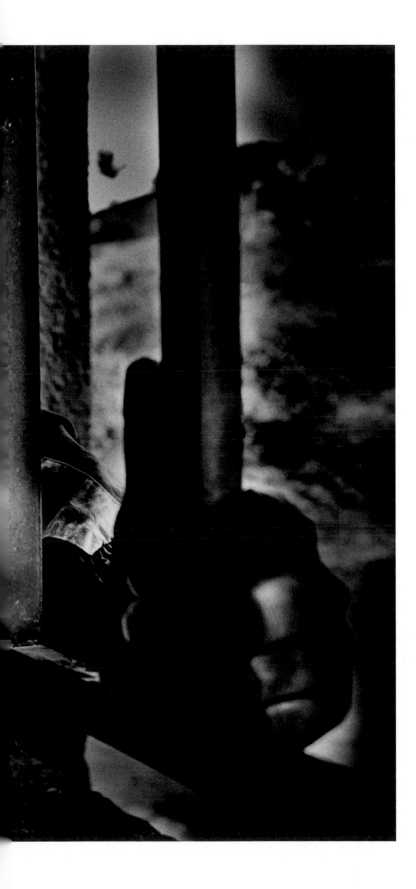

"One day I listened to Musekeweya on the radio. I listened to how villagers deal with their conflict and I began to understand what must be done in our villages," says Jean-Claude Mutarinda, who hails from the Hutu village of Giheta. He was too young to participate in the genocide, but his older brothers took part. "The start was for his people to ask the villagers of Rusete for forgiveness. I told them that the weapons used to destroy the village must now be used for rebuilding. We planted seeds for them. On the first day, one hundred villagers from Giheta joined us. Some said: Claude, do you want the Tutsi survivors to kill us? But the next day, when they saw that there was no problem, two hundred people showed up."

"Musekeyewa has helped me forgive without expecting something in return," says Daphrose Mukarubayiza, a Tutsi woman who was widowed during the genocide. "As a representative of a small committee of survivors from this region, I was asked for forgiveness. Once I forgave, this started a new chapter of harmony."

People beyond the country's borders, such as refugees from Rwanda in the Congo, also listened to Musekeyewa, and it gave them the courage to return to their homeland.

Eighty percent of Rwandans listen to Musekeweya every week. The future belongs to a new generation that was born after the genocide and was not exposed to the daily hate messages of Radio des Mille Collines, but to the stories and songs of hope and reconciliation.

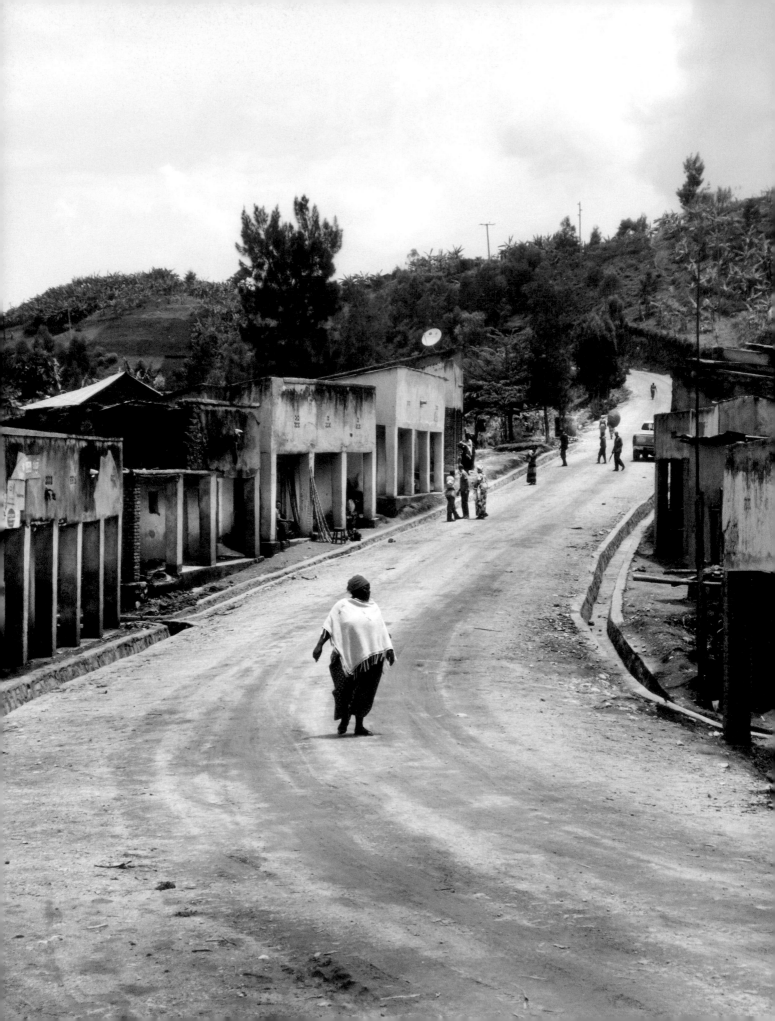

JACK B

Jack Rugamba was born in 1985 in Nyamirambo, a slum neighborhood in Kigali. His parents are Tutsi. Jack's first memory is the arrest of his father. The Hutu government accused him of being a spy for the Rwandan Patriotic Front (RPF). "They called him 'inyenzi,' a cockroach. My father listened to the music of Cecile Kayirebwa, and that is why they suspected him."

Cecile Kayirebwa is a Rwandan singer who, as a child, fled to Belgium with her mother due to the increasing violence against Tutsis. Her music is very encouraging to Tutsis in their homeland, but whoever openly listens to her is associated with the RPF. "When my father got drunk, he would play this music very loudly. He totally ignored the warnings of a neighbor. He said that they were going to get rid of us anyway — the only thing we still have left is a bit of pleasure."

Jack's father sat for a while in prison. When he was released, his health quickly declined. "I heard him say that they poisoned him in jail." Less than a month after he got out, Jack's father died. In 1993, Jack's mother also became ill, but Jack was still young at the time and can't remember much.

These were bewildering and turbulent times in Rwanda. Jack's mother died in the hospital and was buried on April 6, 1994. "Family members from all over the country came to Kigali. We said goodbye to my mother and before I actually realized that I was an orphan, something terrible happened."

On the day of the funeral, the plane carrying President Habyarimana was shot down, and that evening the genocide began. Jack's family hid him in a pit behind the house. He remained there for a few days with a few other Tutsi cousins. He heard how neighbors and friends were murdered.

One evening, Jack's aunt took him out of the pit because they had arranged for a hiding place at the home of a Hutu uncle who had married into the family. Because they feared for their lives, they had

to circumvent roadblocks. When they arrived at his uncle, his aunt quickly left; that was the last time he saw her.

Jack was confined to a back room in his uncle's house where there was a small child's bed. He could see a bit of the valley below through a tiny window. Jack gazed for hours outside, saw gun battles and horrific scenes. One day, Hutu militiamen stormed in. "They searched all the rooms and asked who I was. My uncle insisted that I was his son, and luckily, they believed him."

Jack was stuck in that room from April to June 1994. "Suddenly, my uncle rushed in, grabbed my hand and ran outside. The streets were full of people fleeing away with their possessions. I had no idea why." It was the beginning of July, the RPF of Paul Kagame was on the verge of capturing Kigali and the Hutus started to flee in masses. Jack is a Tutsi and should actually not have feared the rebel army, but since he had lived under the Hutus, his life was also in danger.

In the turmoil, he lost his uncle. Thousands of Hutus walked to the edge of the city in order to escape to the mountains. Jack followed the stream. The rebels reached the edge of the city and shot everyone they encountered indiscriminately. Jack tried to escape via banana plantations that ran parallel to the main road. "If you dared to cross the road, you were shot dead. I saw soldiers everywhere. I made myself as invisible as possible and walked further, protected by the large banana leaves. It was horrible. Mothers called out to their children and helpless children to their parents. I was alone."

By morning, Jack was able to reach the top of the mountain. He continued to follow the refugee stream, but did not realize that he was on a journey of more than 124 miles in the direction of Goma, in what was then Zaïre and is now the Democratic Republic of the Congo. His feet were swollen, and he hardly had anything to eat.

After three days of walking, he crossed the border to Zaïre. Jack subsequently lived for three years in a refugee camp. Every day, he went deep into the woods to gather charcoal. It was every man for himself. A group of Hutu men discovered that he was a Tutsi. When Jack found out about their plans to murder him, he fled back to Rwanda. In Kigali, his own brother no longer recognized him. Fortunately, his grandmother, who thought he was dead, was deliriously happy to see him.

Jack focused on dance in order to forget the horrible years. He spent entire days mimicking the dance steps of Michael Jackson. In his teens, he discovered that he had singing talent and called himself "Jack B." He contacted Jackson Dado, a Rwandan producer, and begged him to record his song "Where Are You?" Jackson agreed and recorded a video clip of the song. Without Jack being aware, the clip was shown on national TV. "Suddenly, everyone started to approach me. They thought my song was nice, but I didn't know that it had been on TV. The song was about my three years as a refugee when I had to work hard in the woods of the Congo while my family thought I was dead."

Jack scored a few modest R&B hits in Rwanda, but could barely survive from his performances. "I would like to write a book about my youth, but I was not able to go to school, so my vocabulary is inadequate. Through music, however, using simple texts, I am able to convey my feelings."

As a child, Jack experienced the darkest days of the genocide, but he believes in another future for Rwanda. "My latest song, 'The White Color,' is about love between a Hutu and a Tutsi."

"I would like to write a book about my youth, but I was not able to go to school, so my vocabulary is inadequate. Through music, however, using simple texts, I am able to convey my feelings."

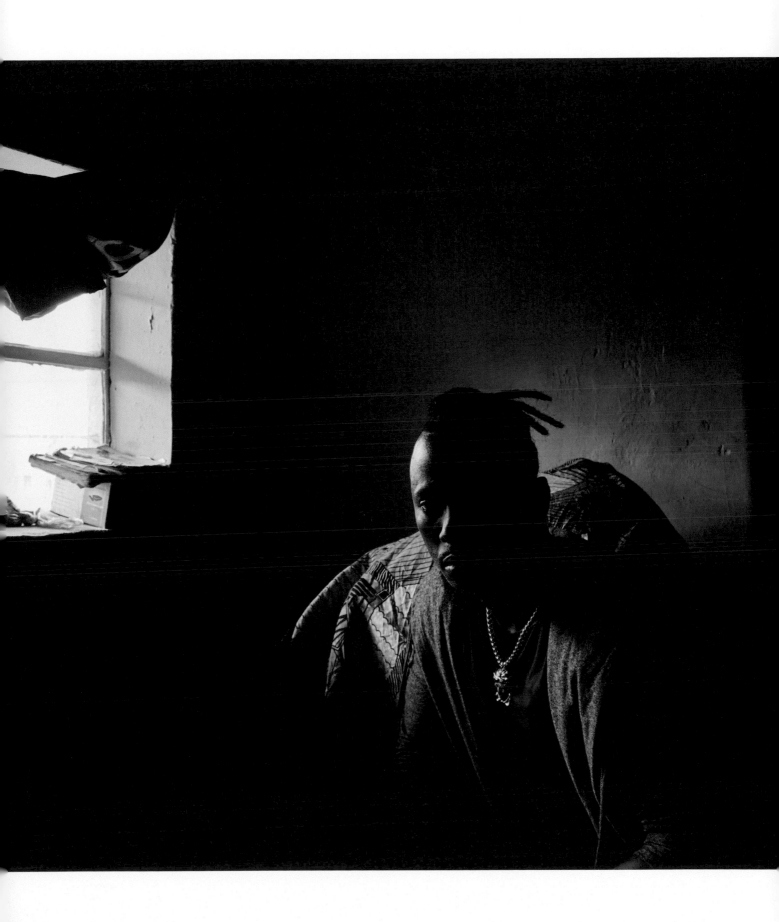

"As an artist, it is my moral duty
to heal the wounds of Rwanda."

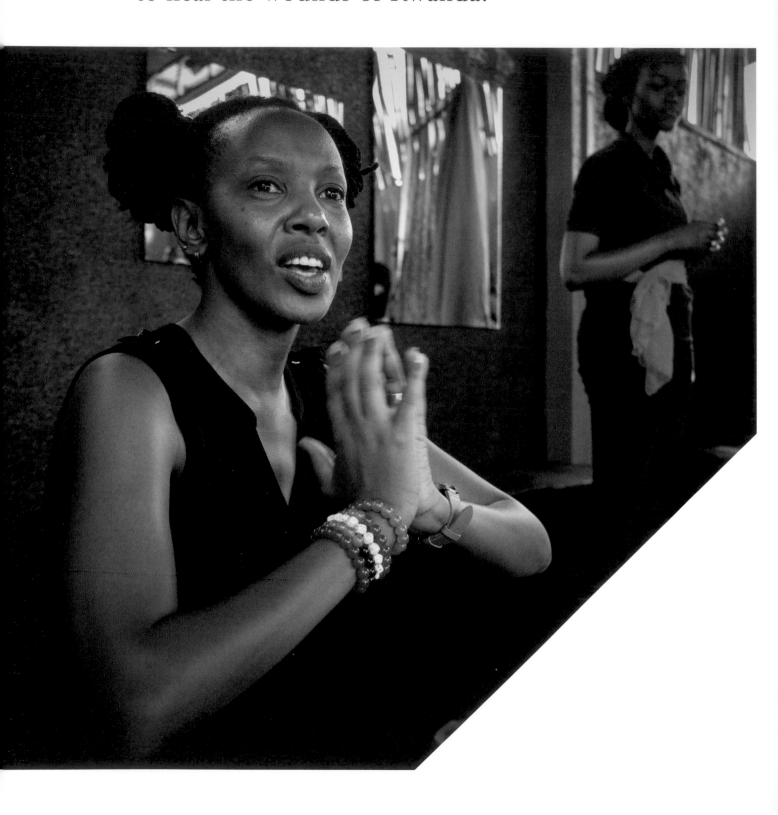

HOPE AZEDA

Hope Azeda's theater career began in a small class under a tree in Kigali, because there was no classroom. Today, she is one of the most prominent theater directors in Africa, and in October 2018, she had an article published in Time Magazine.

Hope Azeda grew up in Uganda. Her parents fled from Rwanda in the early 1960s due to ethnic violence. They first lived in a refugee camp, but managed to give their children a relatively normal life outside of the camp in spite of the tension between the refugees and the local population.

"Sometimes I was jeered at, but my parents did their best to keep us from feeling like refugees, and they focused on our development."

That was not simple. Her father was a teacher, but at school he was sneered at because his English was not perfect. Hope began lying to herself and others that she was Ugandan in order to be accepted. She concealed her Rwandan background. "I lived in denial and behaved as a Ugandan to avoid being ostracized. Unconsciously, I began to dream of returning to Rwanda."

The things she heard about her homeland were not encouraging. One day, she saw a photo of a fat fish in the newspaper. "They wrote that the fish in Victoria Lake had become very big from eating dead bodies" — bodies that originated from the genocide in Rwanda. During that period, her eight older brothers all left home to join the RPF rebel army.

From a young age, Hope felt an artistic fire burning inside her. If she had a fight with her parents, she would write about it in her poems. "I gave these to my parents as a way of explaining how I felt." Hope's parents were not happy about her artistic ambitions and wanted her to strive for a normal job. But at school, she wound up in the theater. She became an

actress and quickly developed her career. "When my parents saw me on TV, they were proud of me and realized that they must give me the chance to follow my dream."

In 1997, Hope returned to Rwanda, but at that time there was no place for art or theater in the broken country. "At first, people didn't believe that I was Rwandan, because Azeda is not a Rwandan name. My father had invented that name so that we would be accepted in Uganda. He took the first and last letter of the alphabet and added a few more letters, so it became A-Z-EDA."

Hope started an organization for performing arts. It was called Mashirika, which in Swahili means "combining forces." Hope wants to use her organization to promote social reform: she wants to help people find a way out of oppressive social conditions. She offers an answer to social problems through art – whether it be malaria, AIDS, climate change or genocide.

In 2004, the government asked her to stage a performance to commemorate the 10th anniversary of the Rwandan genocide. She barely had two weeks to prepare the show, which would be performed to 30,000 Rwandans in the Amahoro Stadium in Kigali. "I had never performed to more than 400 people. This was a huge challenge."

Hope managed to organize a performance with 1,000 young actors, dancers and musicians, a feat of strength that underlined her talent. The performance was so overwhelming and traumatic for some of the spectators that they had to leave the stadium. "This was the first time that I had witnessed mass trauma. The Red Cross did not know who to help first. I thought that perhaps we should stop the performance. People were forced into facing the reality of the genocide. But it was like rinsing a wound: it hurts, but it has to be done."

The performance, called Africa's Hope, received international acclaim, and every year it is staged in different countries around the world.

"I wanted to show the genocide from the perspective of children who survived and children who were born after it. They want to know why and how it happened so as to ensure that it never happens again. They bear a heavy responsibility, and this is why they deserve our answers."

Nowadays, Hope also writes pieces that are not related to Rwandan history. The responsibility an artist feels when working on the history of Rwanda is sometimes too much to bear. "Just before my father died, I asked myself how long I could continue to go on with this. He said: 'Your history is your shadow, and you can never shake it off.' He was right. As an artist, it is my moral duty to heal the wounds of Rwanda."

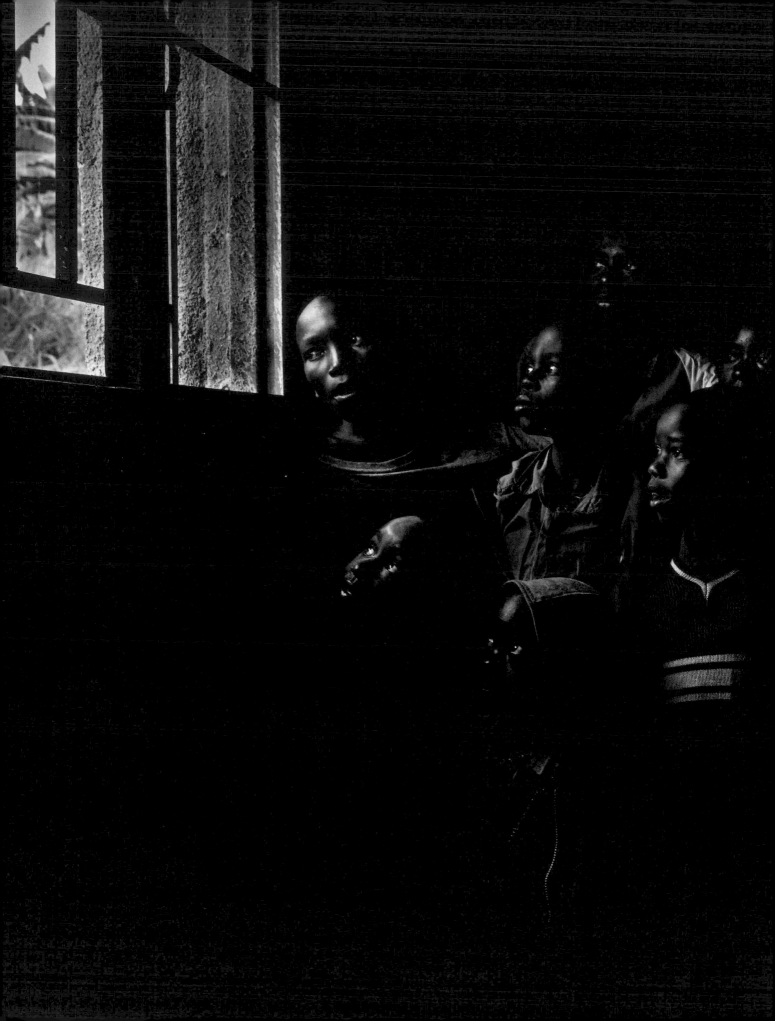

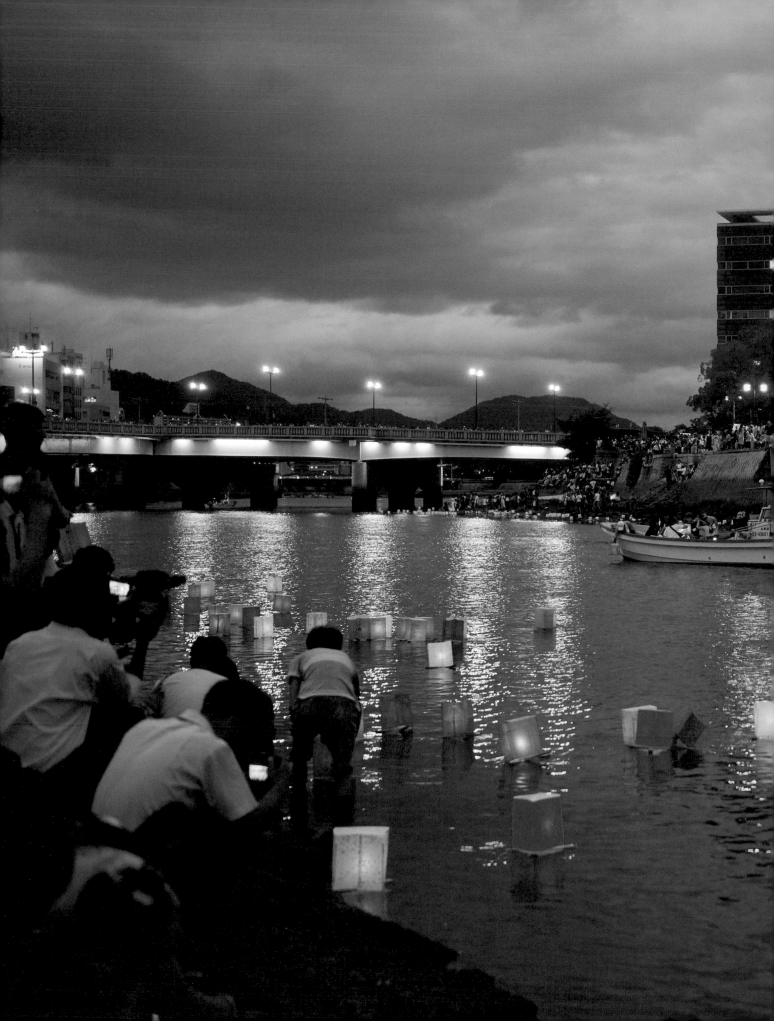

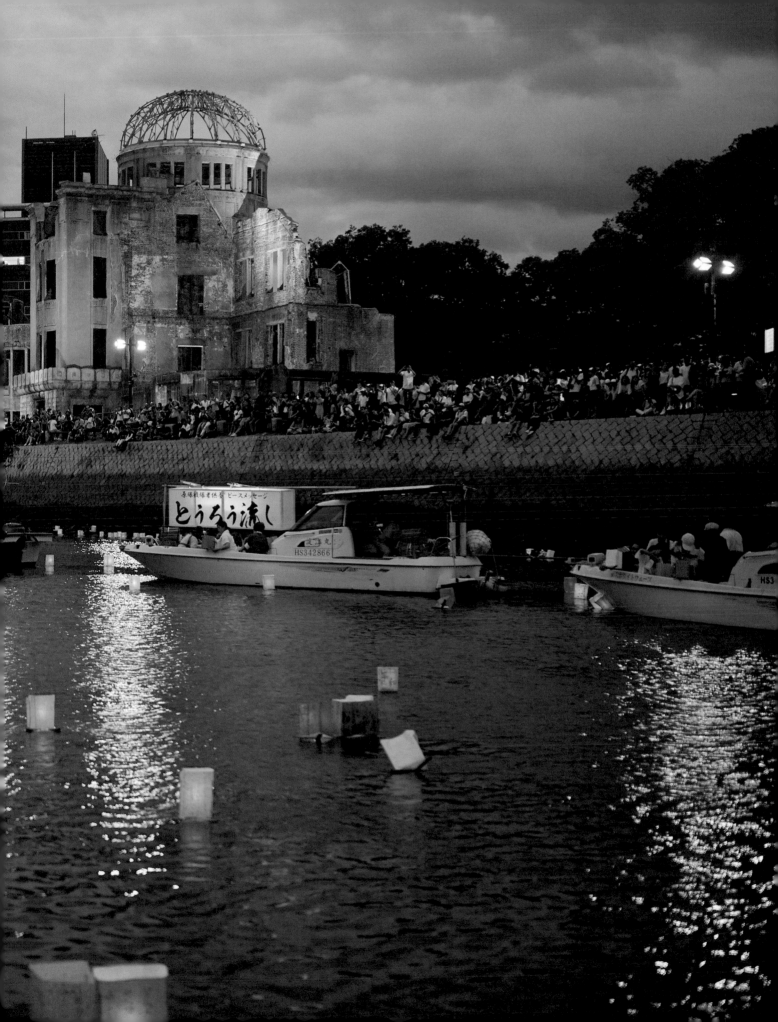

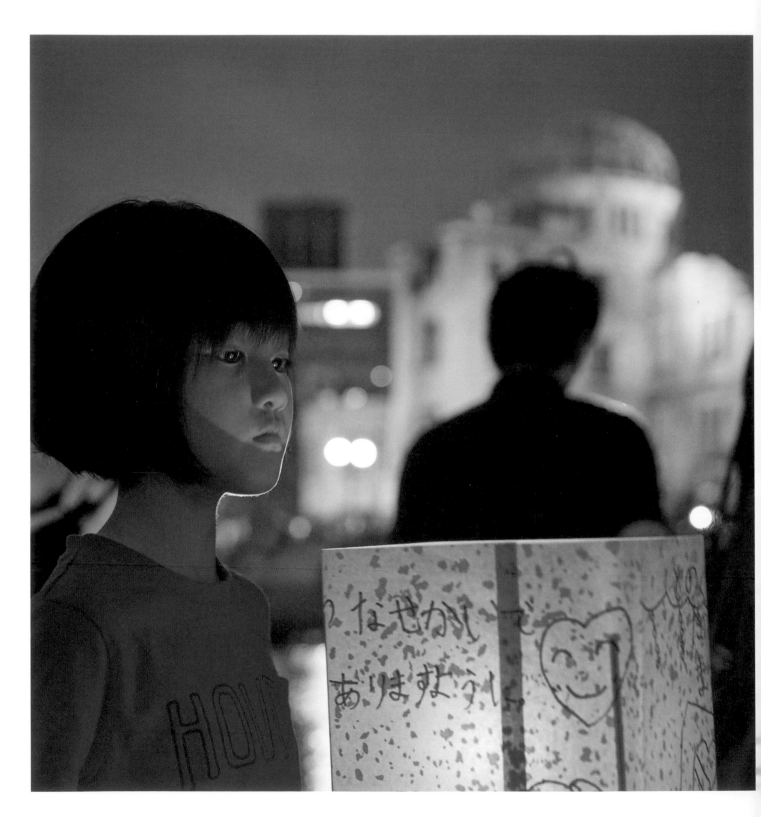

V. Hiroshima

In 1941, Japan's surprise attack on the American naval base in Pearl Harbor marked the start of the Pacific War, and the United States and Japan were promptly drawn into World War II.
In 1942, the situation became increasingly hopeless for Japan, but it speculated on the restraint of the Americans to dispatch ground forces. The US had been secretly working on a weapon intended to give them an edge over the Nazis, but because the Nazis were close to total defeat in 1945, the atomic bomb was used against Japan. There was a shortlist of four targets: Kyoto, Yokohama, Kokura and Hiroshima. Kyoto was dropped from the list because of its historical value, and Hiroshima became the first choice.

On July 26, 1945, America, Britain and China released the Potsdam Declaration calling for Japan's unconditional surrender and stating that otherwise, it would suffer utter destruction. Japan refused and its fate was sealed: the bomb would be dropped.

On the morning of August 6, three B-29 bombers took off from the Tinian Island in the Pacific Ocean: one plane with measuring instruments, a second plane that would shoot images, and a third plane, Enola Gay, which carried "Little Boy," the euphemistic nickname for the uranium bomb. The Japanese noticed it, but were not alarmed, thinking that it was just another reconnaissance plane.

Earlier that morning, a reconnaissance plane had flown over Hiroshima to check the weather conditions. The fact that it was a clear day sealed the fate of the city. When the reconnaissance plane flew over, bomb alarms sounded and the residents fled to air-raid shelters. Twenty-two minutes later, the alarm was switched off and people began their day. When Enola Gay approached, the alarm did not sound again. It is estimated that around 350,000 people were in the city at the time.

At 8:15 am, Little Boy exploded two thousand feet above the center of Hiroshima. A flash of light blinded the residents. The atomic reaction created a fireball with a core temperature of over one million degrees Celsius. The temperature in the city heated up to more than three thousand degrees. The heat and pressure created a supersonic shockwave.

Everything burst into flames, up to a radius of three miles from the explosion. The outlines of people incinerated in the bombing left shadow imprints on the asphalt. The radioactive radiation caused decades of suffering. The death toll is estimated at 140,000, but the total number is much higher due to radiation sickness.

On August 9, a second atomic bomb followed on Nagasaki; shortly thereafter, Japan surrendered.

Hiroshima was rebuilt within ten years. In the hypocenter of the atomic bomb, the spot of the explosion, a large peace park with a museum was established, close to the ruins of Genbaku Dome (or A-Bomb Dome), one of the rare buildings that survived the explosion.

The disaster is now three-quarters of a century behind us, and so there are few survivors, or hibakusha. Some have not spoken for decades about that tragic day, but are now sharing their stories so that the world will never use atomic weapons again. Hiroshima is an iconic city in promoting world peace. Since 1945, music has also been used to protest or warn against another nuclear war. During the Cold War, for example, there was a remarkable number of songs about the horror of atomic weapons. The list of musicians who sing about the theme is long: The Rolling Stones, Metallica, The Clash, Depeche Mode, Talking Heads, David Bowie, Genesis, Pink Floyd, Sepultura, XTC, Queen, Europe, Duran Duran, INXS, U2, Sting, The Scorpions, Nena, Iron Maiden, Prince, Randy Newman, Kate Bush, Tears For Fears, Bob Dylan, Billy Joel, Steely Dan, The Who, Morrissey, Black Sabbath, The Byrds, Pixies, Eurythmics and many more.

OSAMU MUNAKATA

Osamu Munakata is the last descendent of the family line of the Special Kampei of the Grand Shrine of Munakata. His ancestors were considered descendants of the Sun Goddess Amaterasu, considered the most important god in Shintoism, the indigenous faith of the Japanese people.

Osamu grew up in Hiroshima. His mother was a singer in the traditional Noh theater genre, a stylized dance drama from the fourteenth century. His father was a flutist and taiko drummer in a Shinto shrine. Taiko literally means "big drum," and its use probably dates back around two thousand years. During the feudal period, taiko drums were used to motivate the troops and to give orders. Nowadays, taiko is interlaced with theater and art.

When he was 15 years old, Osamu mastered the art of Noh theater and taiko drumming so well that he became a grandmaster. Nowadays he gives weekly taiko lessons to people from all over the world. Osamu is addressed as sensei, which means master.

When he was seven, Osamu had an experience that he rarely talks about. On August 6, 1945, he was at home, nearly 2.5 miles from where the bomb fell. He was blinded by a flash of light, and immediately after the flash, the windows of his house smashed to pieces. Young Osamu looked upwards and saw only black and red clouds. He ran with his younger brother and sister to the air-raid shelter in their yard. His mother had gone to the market, and his older brother had been called up to dig air-raid shelters near the city center. Osamu thought that the nearby automobile factory had been bombed, but then his brother came home with a swollen head and skin hanging like big patches from his body. Even his palate was burned. His mother came home less tattered, but she did not yet know that she had been exposed to a large dose of radiation.

Osamu thought that his brother would die. For weeks he took care of him, feeding him with a straw. It was striking how many people who were not heavily wounded suddenly collapsed and died. In the first days, no one realized that it was an atomic bomb and people referred to it as a "flash-bang."

Mass cremations occurred nearby. "If you suddenly collapsed, the soldiers would assess whether you had a chance of survival. If they had doubts, they took you away alive to the cremation site." The smell of the cremations was the most repulsive odor that Osamu had ever experienced. "A penetrating fat stench blew our way each day. I could no longer eat any fat. We called it grave air."

Because he needed to care for his brother, Osamu had to give up taiko drumming and the Noh theater for a number of years. His brother had numerous skin graft procedures on his face.

Meanwhile, Osamu's mother became very sick. She developed leukemia, radiation sickness and tuberculosis. The family decided to move to their vacation home in Oyamura, where the air is better. They also decided not to talk about the atomic bomb anymore, because people believed that survivors were infectious. Osamu would be chased away. "Go away! Stay out of our neighborhood!"

This discrimination hurt Osamu. He withdrew and focused on the health of his family and took up Taiko drumming and Noh theater again. His mother did not survive her illnesses, but his older brother, despite his severe injuries, would live to the age of 73. When he was 30, Osamu developed intestinal cancer. "Everyone in our area developed cancer sooner or later. The doctor said that I would most likely die, but thanks to surgery and my good spirits, I was cured. Taiko and Noh healed me."

Munakata Sensei is one of the last great taiko masters. He is over 80, but continues to practice his passion diligently each day. He refuses to think about the atomic bomb. "I have seen too much sorrow in my family. I teach Noh and taiko in order to forget it. I want the pain to stop, lock it up inside of me. Now that I have said this, let's end the discussion about the atomic bomb. The future beckons us. This is the last thing that I will ever say about this subject."

In his home, Munakata has reconstructed the Noh podium of the Miyajima shrine, a holy shrine on the island, not far from Hiroshima. He teaches students several times a week. During those lessons, discipline and style reign, but after ... Munakata takes his students to a karaoke bar. After a few drinks, they put the empty noodle bowls on their heads and sing popular Japanese songs with him. Munakata roars with laughter.

The next morning at dawn, he stands outside to greet the sun. He puts his hands together and claps them twice in a controlled but powerful manner. "Glad to see you, Amaterasu, goddess of the sun," he says to the rising fiery ball that makes life on earth possible.

"I want the pain to stop, lock it up inside of me."

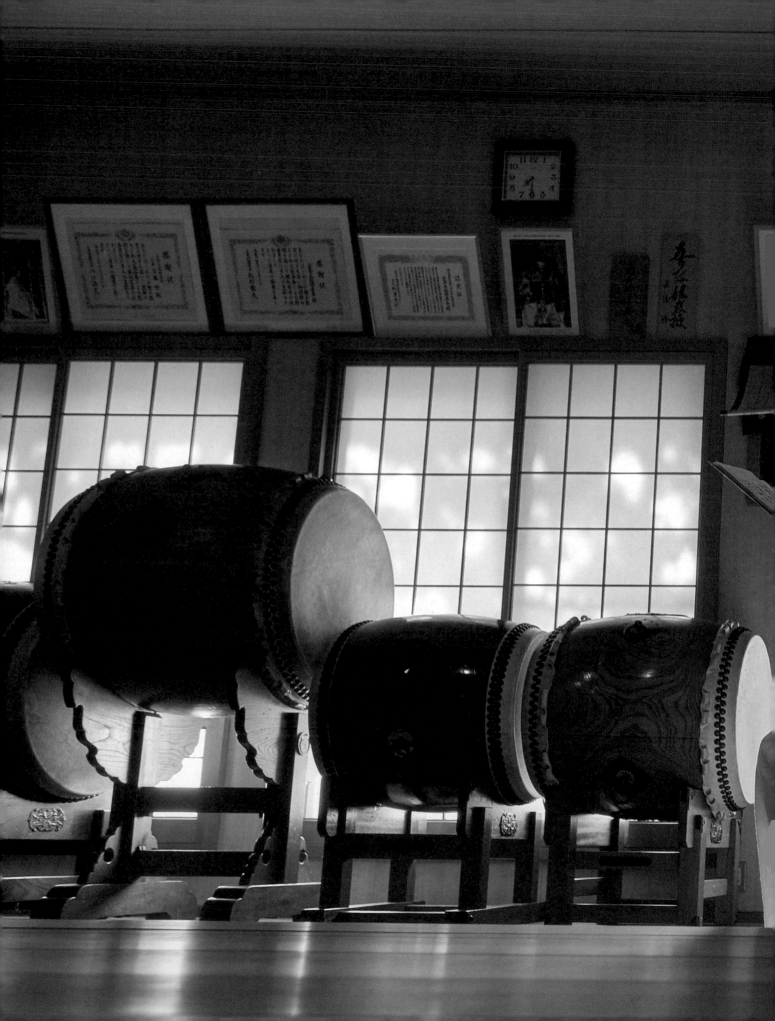

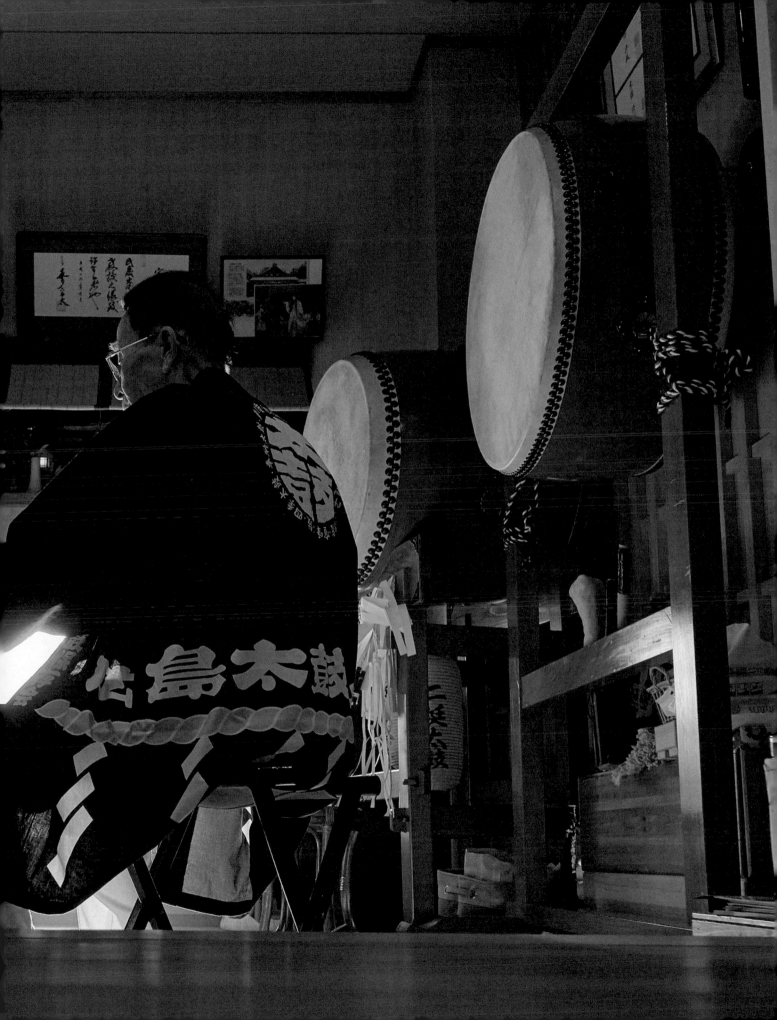

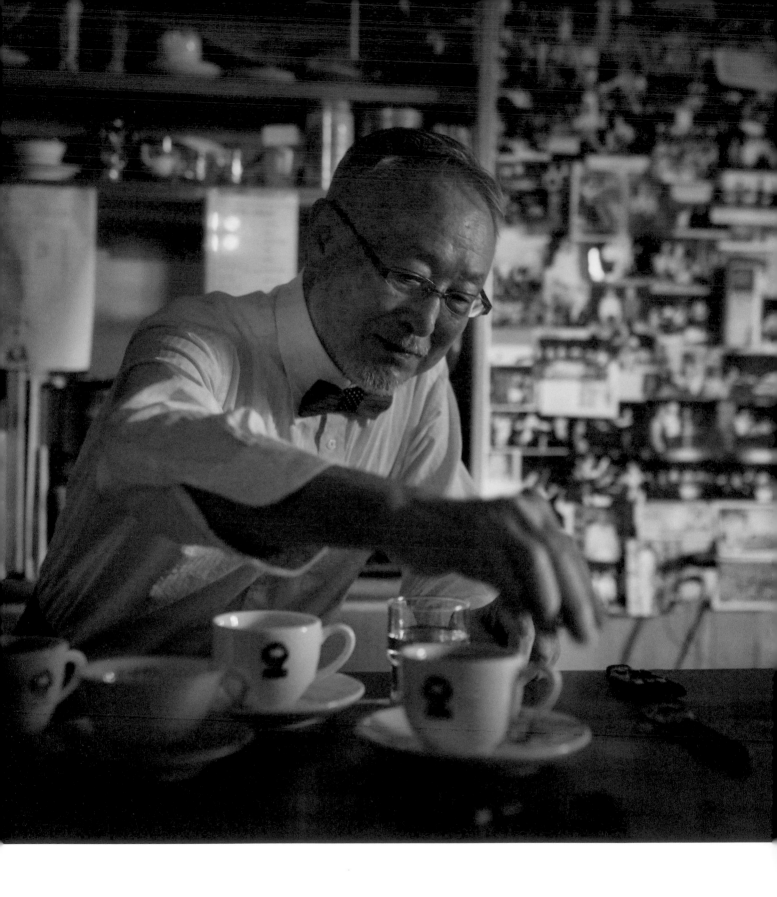

TADAKATA YANAGAWA

In an obscure alley close to Hiroshima Station, you will find an unusual coffee bar, with no visible signs on the façade indicating that it is a coffee bar. A thick tapestry of ivy hides the gray walls. To the right of the door, a picture of Beethoven flaunts the bar. A blue-red neon light displays the Japanese name ムジカ, which means "Musica."

Behind the bar sits Tadakata Yanagawa, wearing a neat suit, a shirt and a wooden bow tie. Posters of classical concerts hang everywhere. The place radiates tranquility, and Tadakata is his kindhearted self. He is a certified barista, and he serves the coffee with such control that it has become a form of meditation for the customers. Tadakata is a man of few words with a polite smile on his pleasant face.

Upon request, he opens the double wooden doors to the right of the bar. Beyond the doors is a room many times larger than the bar. It is a hall for classical music. A record player and a CD player sit on an old desk in the back. Around it are cupboards with hundreds of CDs and LPs. In the hall are dozens of small tables with chairs. People sit there quietly reading, listening to the music with closed eyes or eating their lunch while enjoying their coffee. There is no talking. Up front is a small stage with a grand piano, and above it, a plaster bust of Beethoven looks sternly over the hall. After the atomic bomb, this was the first bar that opened.

Tadakata was two and a half when the bomb fell. Years later he heard how his mother, pregnant with his sister, threw herself on top of him to protect him. She was pierced by glass fragments but managed to protect her son. His grandparents died from radiation. Tadakata's father, Yoshio, was cycling in the center of town, but miraculously survived.

Tadakata's earliest memories are half a year after the bomb. There was a famine, but his father always came home with food. "In 1946 everyone was busy surviving and rebuilding the city. My father thought there was too little mental input to take on great challenges."

Yoshio listened to records from a young age. Beethoven was his idol. But after the bomb, all the music disappeared: records melted, instruments were destroyed. For many months, no music was heard in Hiroshima. Eventually, Yoshio gathered some cultured people, and together, they established the International Cultural Association of Hiroshima. "They felt that we needed music and culture."

> "Inside Café Musica, it was paradise,
> but a few steps further outside,
> you encountered a horrendous world."

On August 25, 1946, Yoshio opened a music teahouse in a structure that he built himself. No one had money for coffee or tea so he let people pay with what they could. A draftsman paid with a drawing, a poet with a poem. American soldiers gave him coffee and chocolate. "Inside Café Musica, it was paradise, but a few steps further outside, you encountered a horrendous world."

The only thing missing was music. Yoshio wanted to play Beethoven's Symphony No. 9. That was his favorite piece, especially the choral finale, "Ode to Joy." He heard that he might be able to find a 1925 recording of Symphony No. 9 on the black market in Sannomiya. He could not contain his joy when he got hold of the record. Back in Hiroshima, he saved it for a special day: New Year's Eve.

Four-year old Tadakata was a witness to the first time that "Ode to Joy" was heard in Hiroshima since the explosion. "The hall in Musica was full. People could not believe what they were hearing. It is a sad piece, but according to his father, there is a happy message even in suffering. What we endured was severe, but the record symbolizes the light." The sounds enticed more and more people to Musica. Once the hall was packed to capacity, people stood outside and watched the turning record through the window. "That evening, it snowed. The snow fell on the eyelids of the people outside and melted. It looked as if they were weeping." The customers inside listened with their eyes shut. "One customer said that for the first time after the bomb, he felt alive again. Father became even more aware of the power of music. That evening was my inspiration to make music a part of my life."

New Year's Eve 1946 became legendary in the cultural circles of Hiroshima. Each year, on December 31, Yoshio would play Symphony No. 9. He ran the bar for twenty years until Tadakata left his job as a bank clerk to take over Musica.

In 1998, Yoshio died of a stroke. Tadakata has managed Musica for more than 53 years and still plays Symphony No. 9 on New Year's Eve. "During the period after the bomb, when there was nowhere to hang out, people came here to listen to music and re-energize. People called it the recharging period. But I am getting older and I have no successor."

In 2020, Musica will shut its doors. Tadakata wants to give away all the furniture, decorations, records and CDs, even the iconic Beethoven record. "The memories are in my heart. I did what I could, but now I must prepare for my own end."

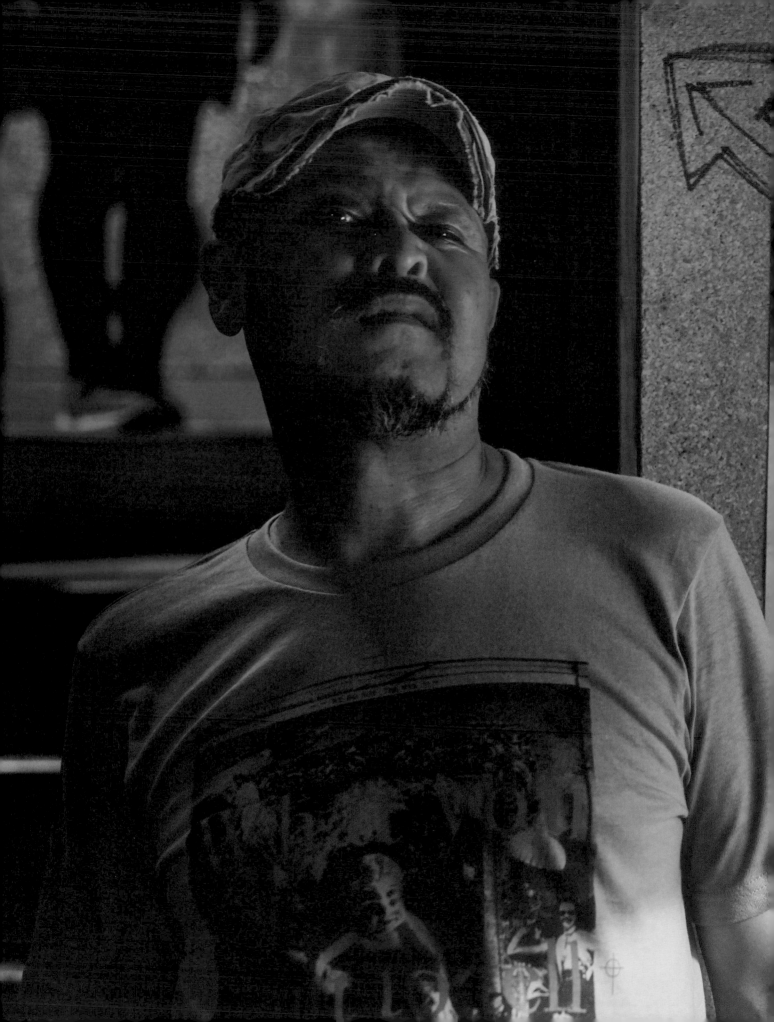

SHINJI OKODA

*Shinji Okoda has an obscure records store in the center of Hiroshima.
He sells mainly punk and hardcore. Since punk fans are hooked on
analog music, he hardly bothers with digitalization.
Shinji's parents were children when the atomic bomb was dropped. A few
days earlier, due to fears of bombardments, they were evacuated along with
other children to the mountains, nearly 20 miles away. From the mountains,
they witnessed the mushroom cloud rise above Hiroshima. But they never spoke
to Shinji about the atomic bomb, only that as children they fled from the American
bombardments. And at school, Shinji was never taught about what had happened three
decades earlier.*

In Japan, and certainly in Hiroshima, the bomb was talked about only with suspicion and reluctance. For the survivors, the memories were far too gruesome. The city wanted to move forward instead of looking back at that dark page in its history.

After the atomic bomb, there was a lot of controversy in Hiroshima whether to demolish or preserve the ruins of the Genbaku Dome, some 500 feet from where the bomb exploded. Due to international pressure, the Dome was not demolished, and today it is the most visited monument in the city.

When he was nine years old, Shinji discovered the Manga comic book *Barefoot Gen* in a bookstore. It was about the life of a boy before and after the atomic bomb. Its theme was the strength of a child during difficult situations. It was quite explicit for a children's story. Nowadays, manga is a very popular genre in Japan, but during Shinji's youth, parents considered it bad reading, so Shinji read it secretly. He finally began to understand what no one wanted to talk about. "I was shocked when I first read the comic book. The chief character was my age, so I identified with him. *Barefoot Gen* became my bible." Shinji became a punk singer, through which he expressed his dissatisfaction with society, but he did not sing about the atomic bomb. Since he comes from Hiroshima, he treads carefully around this subject. In 1999, he was invited to a Hiroshima Peace Event in Tokyo. This opened his eyes, and Shinji realized that he could do more as a singer. To gather more information about the subject, he looked for hibakusha (survivors) who were willing to talk. He put their stories into songs that he produced with his band, Origin of M. The songs are about the danger of nuclear power. "I realize that my music does not reach the leaders, but that doesn't mean I should remain silent. People have been silent for too long. Young people must know what happened."

Since 2004, Shinji has been organizing an annual punk and hardcore concert called To Future, commemorating the atomic bombing of Hiroshima. Hundreds of punk fans come to the event.

Shinji confronts the horror in posters and song lyrics. "In 2011, Japan suffered another nuclear disaster in Fukushima, where a huge meltdown occurred in a nuclear power station. The people in Fukushima are being subjected today to the same discrimination that Hiroshima survivors had to endure. Again, I see the cover-up mentality. The disaster is hushed up in Japan, but I refuse to do that."

"The people in Fukushima are being subjected today to the same discrimination that Hiroshima survivors had to endure."

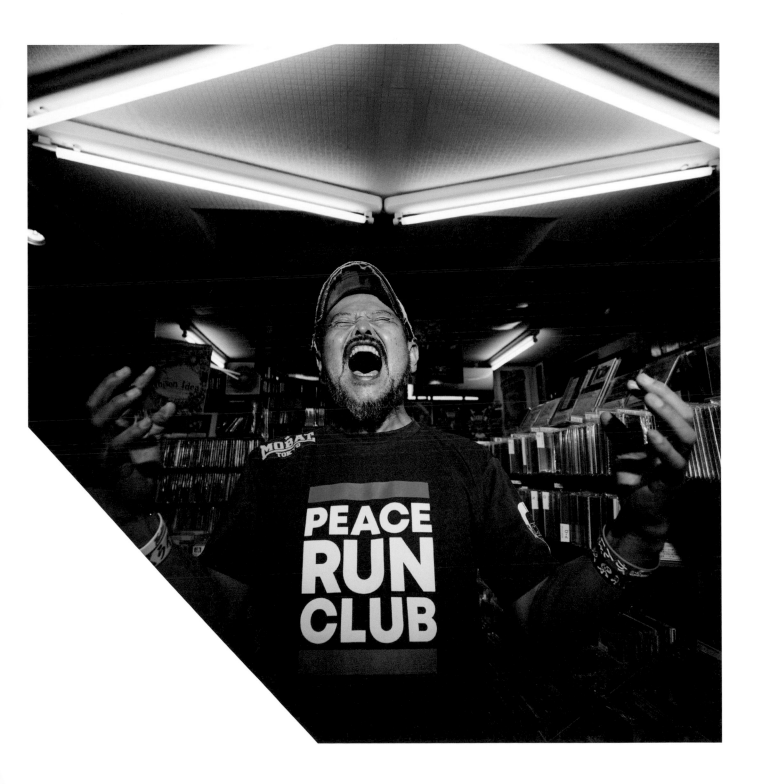

"Music gave us the strength to think about the future."

YURIKO HAYASHI

Yuriko Hayashi was less than a mile from the hypocenter of the atomic bomb when she saw an immense flash of light. She was nine years old and had just left the house with her parents and brother to go to school. They heard a bang, it went dark, and then there was total silence before a wave of screams and shouts came in their direction, followed by an enormous gust of wind. Their house was blown away and they were blasted tens of feet along with debris and glass fragments. Their bodies were full of glass, and blood was everywhere. Their light clothing melted on their skin. All four lay naked on the ground, but still alive. Very few people who had been so close to the hypocenter lived to tell of that day. It was a miracle that the entire family survived.

Yuriko's father urged his family to walk further up the hill. "It was an escape through hell. Fire was everywhere, the entire city was gone and charred wood rained on us. The worst was the bodies. We were naked and we had to work our way over charred bodies. We saw people stumbling, with eyeballs hanging from their sockets. One man held his intestines in his arms trying to push them back into his body. People on fire sprang into the river not realizing that the water had boiled." They forced their way up a steep slope; Yurico saw piles of bodies everywhere. The dying begged for water. Her father filled a bottle with silty water, but a soldier told him the water would make the pain worse. Yuriko's father ignored the warning; it was the last wish of people who in a matter of seconds were going to die. "They were grateful for that one gulp."

The entire family was exposed to radioactive radiation. Yuriko developed radiation sickness. Her hair fell out; she coughed up blood and suffered from chronic fatigue syndrome.

The period after the atomic bomb in the lifeless, hungry city was the worst period in her life. The only comfort was the songs that her father sang to her every night to try to drive away the nightmares. "Music gave us the strength to think about the future. And there was

Café Musica, where I discovered dancing. We went there often when we were young."

A year after the atomic bomb, Yuriko was summoned for a medical examination. She had to stand completely naked in front of a group of American doctors and scientists and undergo all sorts of tests. Every year, they came unexpectedly to her school. "It was so humiliating. I was a teenager and stood there naked in front of these men." They photographed her from top to bottom. "They said it was in order to help me, but later I discovered that I was a human experimental subject. They wanted to examine the effect of radiation in the event of future nuclear wars."

Yuriko has survived breast, esophageal and bladder cancer. Music and dance have helped her through the ordeal. Yuriko has been teaching dance for over 30 years, and now, at 83, she still teaches seniors every week, even on the national broadcasting station NHK. She is a well-known figure, especially among the elderly who follow her exercise classes on TV. "With the help of music and dance I pulled through. They help me forget the horrible memories. I have kept silent for decades, but in recent years, I realize that I must share this. I do this reluctantly, but it is my duty on behalf of the dead to talk about the sorrow. People must not forget how horrific an atomic bomb is."

VI. Detroit

The bankruptcy of Detroit in 2013 was big news worldwide, but in fact, it was just a footnote in the decline of the city. The tragedy that consumes Detroit is far greater and goes back decades. In the first half of the twentieth century, thanks to its auto industry, Detroit's economy boomed, but it eventually shrunk and Detroit became a ghost town. Detroit became a victim of its own success of steel, stone, concrete and unstoppable progress. Racism festered, becoming increasingly more aggressive the more the city declined. Urban renewal projects wiped out neighborhoods where the black middle class had begun to move in. However, these unique, complex circumstances may be why Detroit is perhaps the greatest music city in the world.

Motown is almost as synonymous with Detroit as cars. Berry Gordy built an entire empire from scratch with Motown Records, one of the most successful record labels in history, with singers such as Aretha Franklin, Stevie Wonder, The Jackson 5, The Temptations, Martha Reeves, and Diana Ross & The Supremes. Motown is a portmanteau of "motor" and "town," because Detroit was the automobile city par excellence. This is mainly due to one person: Henry Ford. The car factories triggered the Great Migration. The Afro-Americans in southern parts of the US may have been freed from slavery, but they were still a far cry from true freedom. Fleeing extreme racism and segregation and tempted by jobs, six million southern Afro-Americans moved to the urban north over a period of several decades, to cities such as Chicago and Detroit, bringing with them their beautiful cultural heritage, including southern music genres, such as gospel, blues and jazz. The cold North received a warm music injection.

Nowadays, if you drive through Detroit, it is distressing to see so much beautiful architecture in such an appalling state, and to know that so many white residents have left Detroit. Marsha Music, a historian from Detroit, writes: "They were forced out by a reign of terror that convinced working-class white people that you better get out of Detroit or else the black people are going to come and ruin your life."

As a result of the large-scale "white flight," complete neighborhoods fell into decay. White people looked for their American dream in the residential suburbs.

The car factories also choked Detroit. They needed increasingly larger plants outside of the city. Detroit was orphaned with thousands of derelict houses and dozens of empty factories. The "white flight" created an invisible racial border: 8 Mile Road. Originally, this was a wide paved road which followed the northern city limits of Detroit.

At first glance, there seemed to be nothing unusual about this paved road, except that it cut the city in two. On one side lived the black population (in the city), and on the other side, the white population (in the suburbs). Even during the heyday of segregation, there were no "Whites Only" boards on the road, but black people knew that they would get into trouble if they dared to cross the boulevard to the residential neighborhoods.

Economic and sociological factors ruined Detroit. It became a city of survival, and that was translated into music. It's remarkable how many music genres originate in this city. Detroit is the city of blues and jazz giants. The city of Motown and the home turf of Iggy Pop and The Stooges, MC5, Madonna, Eminem and Jack White. It is also the cradle of techno. The constant battle between industry, people and nature turned Detroit into a creative bubble in which music provided oxygen to the survivors.

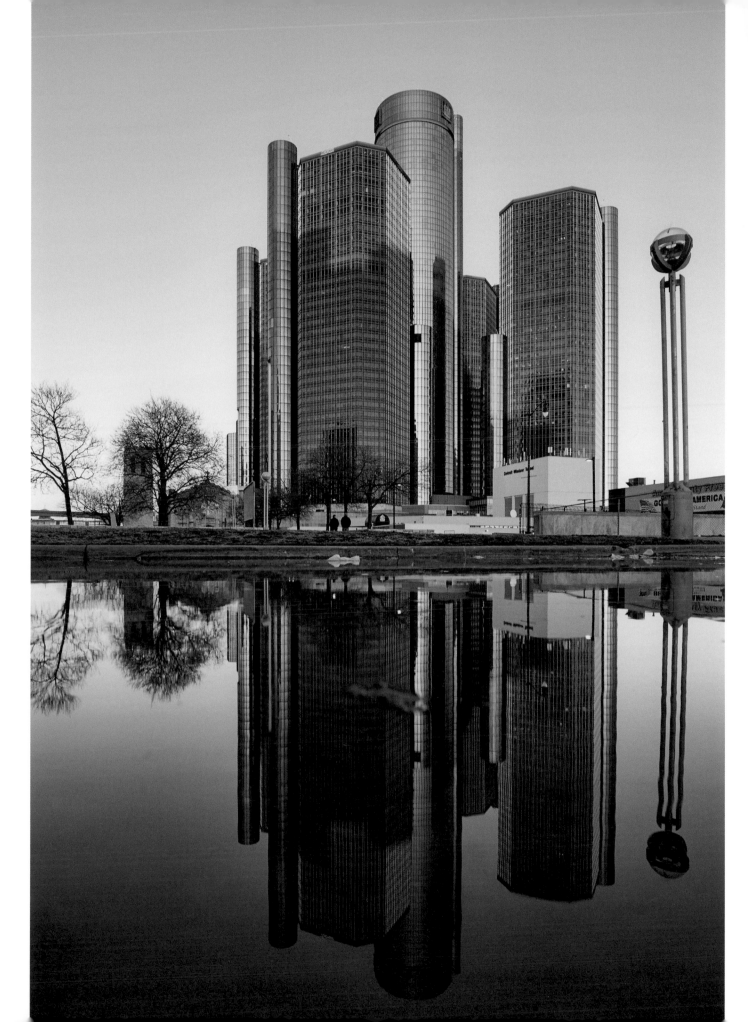

"I write the future.
The future of the Afro black born."

BRYCE DETROIT

Bryce Detroit is a hip-hop performer and music producer from Detroit, who wants to empower his community with artistic storytelling. It's his desire to transform the heritage of native artists into a new narrative, a new future for his underrated community. Bryce is Detroit, and Detroit needs people like him.

Bryce grew up in the North End, a neighborhood in northeast Detroit. The North End got its name due to its being located at the north end of Paradise Valley, a black neighborhood that died in the 1950s due to urban renewal. The local black population cynically called it "negro removal." At the beginning of the last century, the North End enjoyed an unbelievable cultural and economic boost. Its main street, Oakland Avenue, was lined with successful black-run businesses. With the construction of the Chrysler Freeway, the neighborhood was separated from Paradise Valley and consequently declined. You can still feel the grandeur of the old days, but the emptiness is overwhelming. There are more liquor stores than schools. The gas stations function as supermarkets. Along the residential ruins, you see more black squirrels than people.

Bryce Detroit has never known the heyday of his neighborhood. Neither does he recognize himself in the image of the city and its inhabitants that the mainstream media broadcasts to the world. To

him, the bankruptcy of Detroit is a lie that enabled emergency management to take over the city.

Afrofuturism is a motivating narrative for Bryce. This movement recognizes the harsh past that black Americans had to endure, but at the same time sheds it. It is a way for Afro-Americans to define themselves in the present, knowing that this way they will influence the future. The central theme of Afrofuturism is science fiction, because it provides a place in the future for the black people of today. It is characterized by various forms of expression, such as film, music, comic strips, fashion and art that promote an alternative future.

For Bryce Detroit, Afrofuturism is a tool for reaching a higher goal. He uses the power of songwriting to create his own script, a script that must influence others in his city. He recites this script into his microphone: "This ain't no rap song, I don't do rap songs. I write futures for the Afro black born."

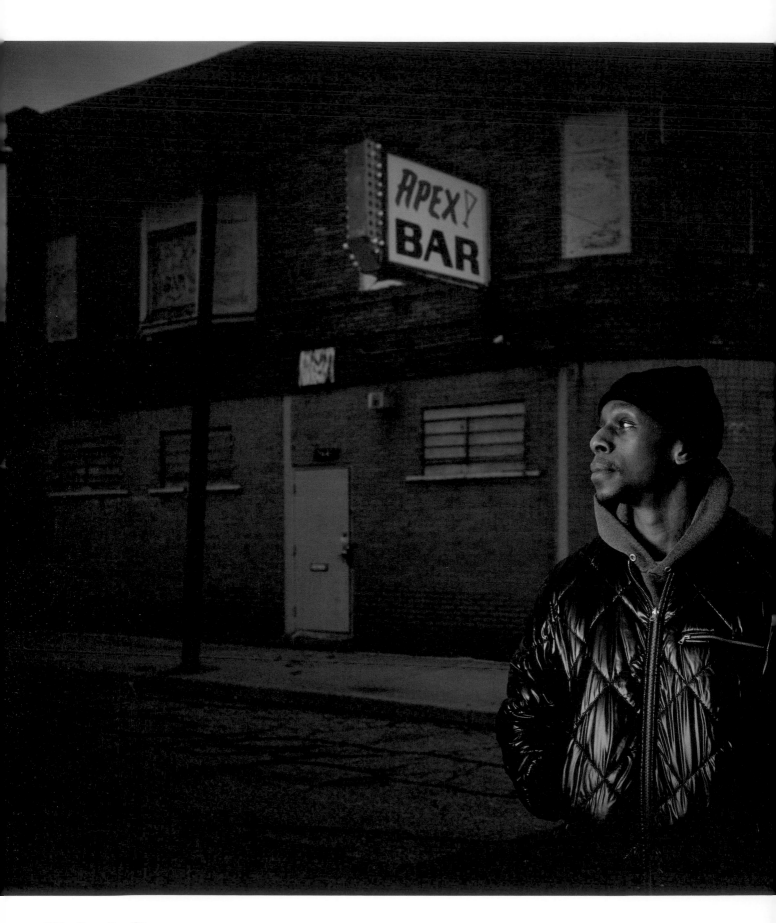

An important step to this new future is revitalizing his neighborhood, the North End. "I want to beautify my neighborhood," he says. Between 2014 and 2018, Bryce was one of the driving forces behind the O.N.E. Mile Project, a multidisciplinary collaboration among artists aimed at breathing new cultural life into the North End. It's no coincidence that the project's location on Oakland Avenue is an abandoned hangar that they renamed The Garage. Inside O.N.E. Mile stands a replica of a golden spaceship, the Mothership. The spaceship is so bright it lights up the environment. O.N.E. Mile has organized hundreds of events, exhibitions and workshops, serving as a lever for investments of more than two million dollars in the North End. And this is precisely Bryce's point. Because no matter how dilapidated the North End looks, it is a potential gold mine for project developers. However, there is one scenario that Bryce wants to avoid: A group of hip artists upgrade the value of the neighborhood, and then project developers come along with their capital and buy everything. This is a common trend in Midtown, the hipster neighborhood of Detroit. The real estate prices there have shot up very high in a few years due to outside investors. No way — Bryce wants the community to hold the reins.

"We are reclaiming the productive building stock and are giving an example: ok, city of Detroit, this is us, activating the space, so work with us. This place isn't abandoned anymore. This is more than just artists activating a space for a good time, this is the beginning of new neighborhood revitalization strategies. It starts with art and culture. This is us, stepping into leadership."

Just over fifty yards from The Garage is Bryce's next challenge. He calls it "Phase Two: The Cultural Revival of the North End." At the corner of Oakland Avenue is the Apex Bar. It is an abandoned property with yellowish tiles on the outside and only a worn-out signboard with its name on it reveals that it was once a bar. The place is full of history; it was the home ground of blues legend John Lee Hooker, who played here countless times, and B.B. King, Miles Davis, Tina Turner, George Clinton and Al Green also performed here often. "It is a challenge for black folk to live here, and this translates into art," says Bryce.

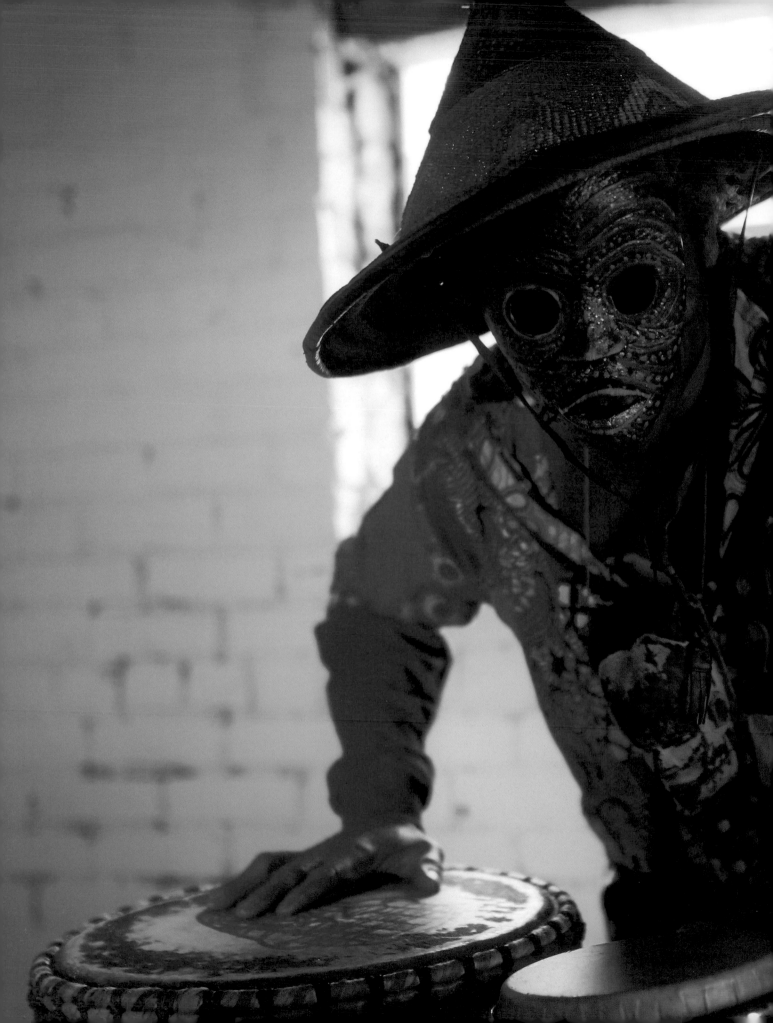

"Racism is an apocalyptic force, but we have a lot of survivors here."

SACRAMENTO KNOXX

Sacramento Knoxx lives on Turtle Island. That is an indigenous name for the land mass that we know nowadays as the United States, Mexico and Canada. The city where he lives is called Waawiiyatanong, also known as Detroit.
Sacramento is a descendant of the Anishinaabe peoples, the original inhabitants of this region. He still speaks their language and calls it the eternal language of Detroit. Sacramento is a pioneer of Indigenous Futurism, a movement that wants an alternative future for Native Americans. "Red land plus black labor equals white gold. If that's the future of this place, we don't get down with that no more."

Growing up in Mexican Town in southwest Detroit was no fun for Sacramento. He lived in "the ghetto," his family was not well off and he saw a bleak future for himself. Yet he has learned one thing: making something out of nothing, or as he himself puts it, "turning shit into sugar."

Sacramento delves into the culture of his ancestors. First, they were massacred, and when that was no longer possible, another policy emerged: "Kill the Indian, save the man. They beat my ancestors with Christianity. Speak English. Stop living off the land. You are American now." The native people were forced to become American. Indian children were taken away from their families and sent to boarding schools, far away from their homes, for re-education. They entered with feathers and left with neckties. Sacramento's grandmother has passed through such a boarding school, and she tells many horror stories about her experience. "Racism is an apocalyptic force, but we have a lot of survivors here," says Sacramento. "Technically I shouldn't be here right now, if the plan would have succeeded."

Sacramento wants to revive his community. Music and other forms of art, such as film and dance, offer him many possibilities. He is a music producer and he calls his style "water." He lets all his musical influences flow through one another into a healing cocktail. Sacramento is the driving force behind the art collective called the Aadizookaan, which means "sacred spirit of story" in the language of the Anishinaabe. For Sacramento, storytelling is the key to making a difference; artists can start the dialog. He organizes workshops and events and collaborates with other principal contributors in Detroit, including Bryce Detroit.

The lack of occupancy in Detroit has its advantages, because Sacramento was able to buy a large property in a public auction for barely five hundred dollars. The place needs serious renovation, but the premises will then become the headquarters of the Aadizokaan. Here, together with his team, he wants to take community work to another level. For now, his improvised studio is in the basement of his house, but stories are not confined to the environment where they are created.

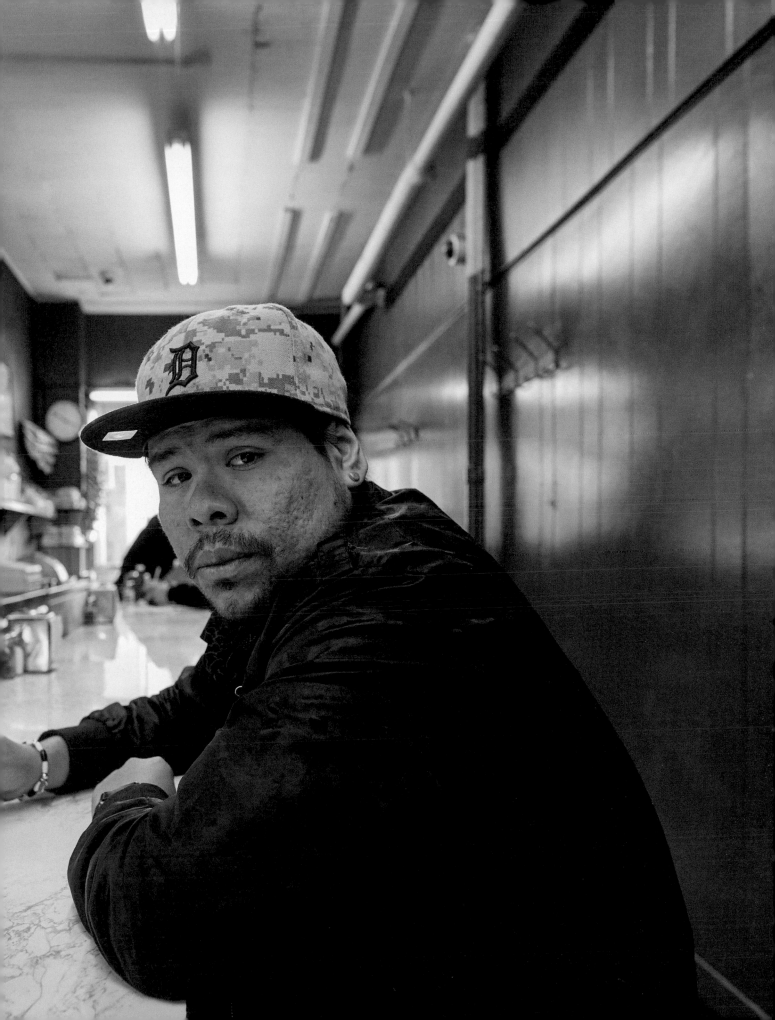

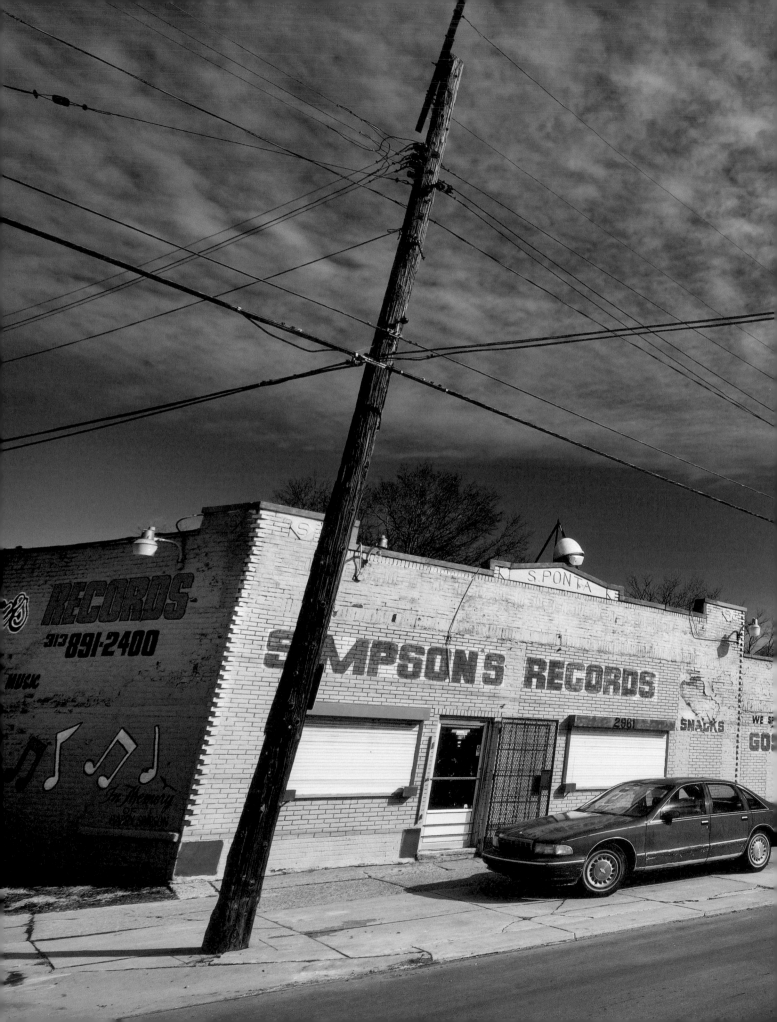

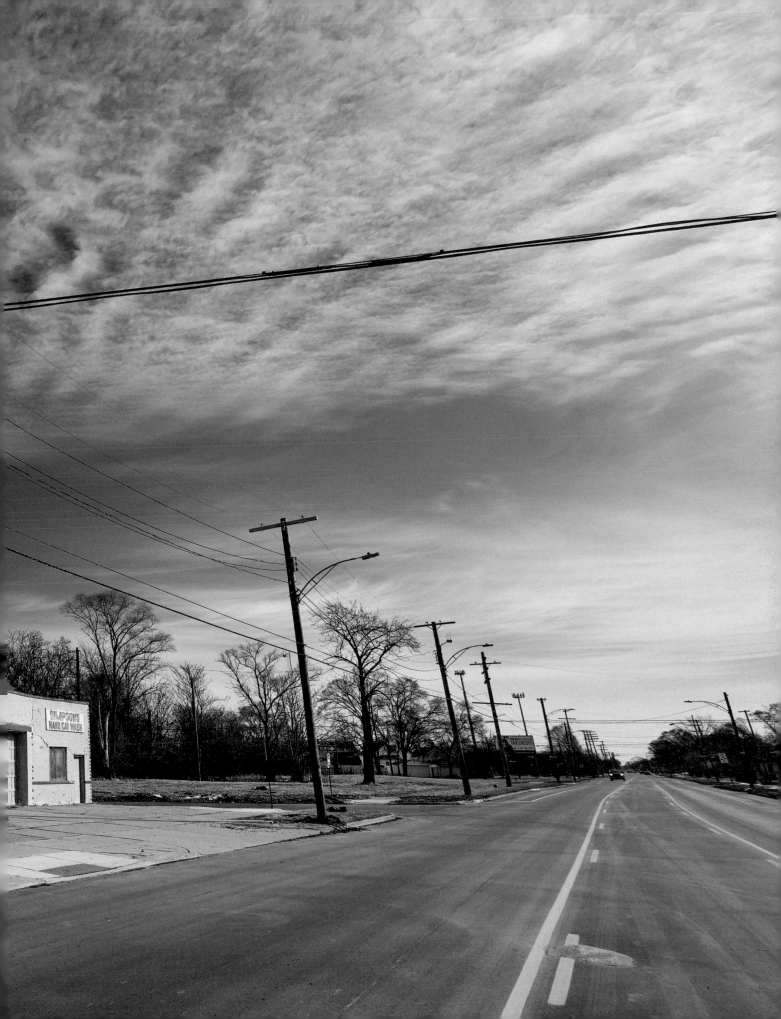

SIMPSON'S RECORD SHOP

East McNichols Road, once a lively boulevard dotted with businesses, looks like no man's land today. There are many empty plots of land where once houses and buildings stood. In the side streets, vacancy is flagrant. There is a large junction at number 2961. At one of the corners, there is a closed liquor store, and opposite is an abandoned gas station. Only the tarmac and roof remain; the gas pumps are long gone. Next to it is a beige building with paint peeling off the front, and on the side is painted: SPECIALIZING IN ALL MUSIC SINCE 1966. Above the front door, the name of this building is revealed: Simpson's Records.

A dented Chevrolet Caprice Classic comes by and stops in front of Simpson's Records. Alice Simpson steps out and helps her mother-in-law, Dorothy Simpson, out of the car. Dorothy uses a walker to enter the store. This is the last day that Alice and Dorothy will open the front door of their store and raise the roller shutters. Alice puts on a CD, and from an old speaker above the building, gospel music blares on the empty boulevard.

In the meantime, Dorothy plucks the dry leaves from the plants. The CD racks are practically empty. Next to the vinyl records are boards with FINAL SALES written on them. Dorothy sits down. "Fifty-two years ... and I loved every bit of it. I like my job, I like my business. I'm going to miss it so much."

It's hard to imagine that Dorothy Simpson was not that passionate about music when she opened her music store in 1966. She was mainly looking for extra income for her family and something that her children could get involved in.

Dorothy had no idea which records she could sell or where to find them. So, she listened frantically to the radio and carefully noted all the most popular songs at the time. She stopped by the local offices of Atlantic Records, Colombia Records, and of course, Motown, who were willing to sell her records in small quantities: two to three per song. She gained a knowledge of music that made her the local Shazam avant la lettre. A customer only had to sing the first notes of a song for Dorothy to know the title and singer.

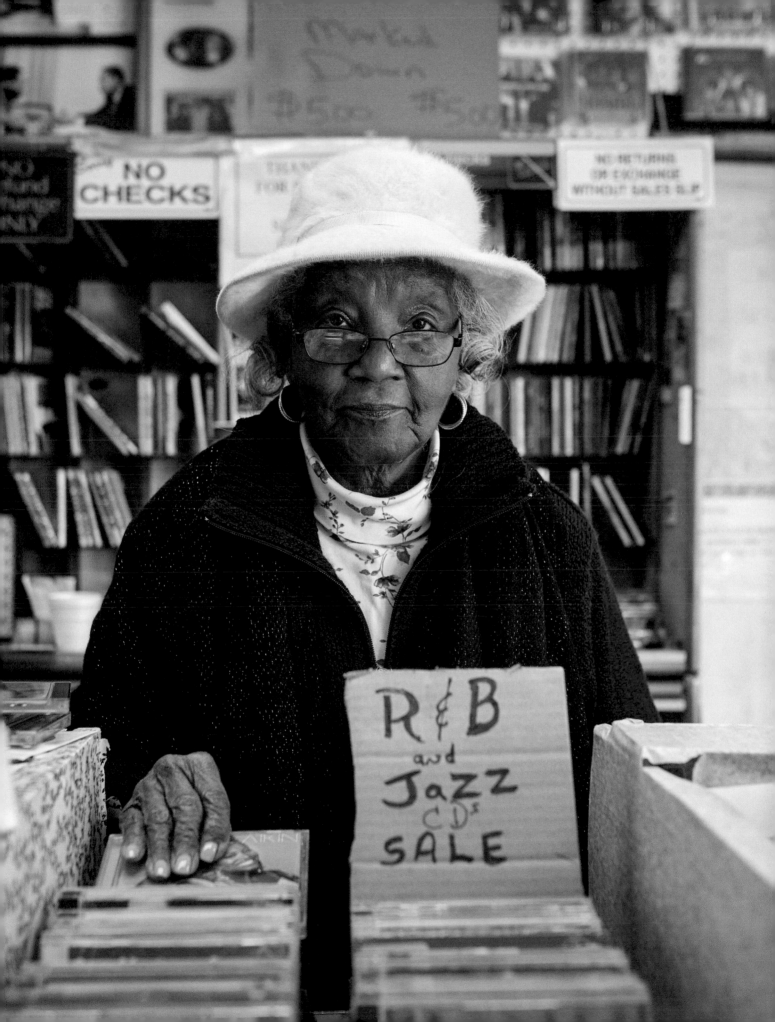

"At first I thought it was for me and my children, but then all of a sudden, it was for me and all children." The large surroundings of the store were plagued by drug dealers and young vandals, but Dorothy knew how to deal with them. "You have to work with 'em," she says with a Southern accent. Kids used to come around begging for money, and Dorothy would assign them tasks in exchange for a few dollars: mopping the floor, cleaning the counter or sorting the records. For many youngsters from the neighborhood, Simpson's Records was their first job. Very soon, Dorothy was nicknamed Mother of the Neighborhood, later shortened to Ghetto Mom.

When the kids became teenagers, they looked out for Dorothy and her store, generation upon generation. "They looked after me. They said to newcomers: don't bother Mrs. Simpson. Don't do that."

Simpson's Records grew into a safe haven in a sometimes hostile neighborhood. One time a man who was followed stormed into the store. "I believe he got shot in the butt," says Alice, the daughter-in-law. But his pursuers did not come any closer. You don't meddle with Simspon's Records, it's a space you don't desecrate with violence.

Just like the rest of Detroit, the neighborhood gradually declined. Families moved away and many were evicted from their homes for failing to pay their bills. Many former residents now live elsewhere, but occasionally some drop by for a visit. One day, Dorothy was visited by a man who asked whether she recognized him. She did not, but he said: "You saved me from going to jail. I was ready to shoot somebody when you came along. You talked to me and made me see things differently. You saved my life."

> "One guy came in one day and said that I saved him from going to jail. Because he was ready to shoot somebody."

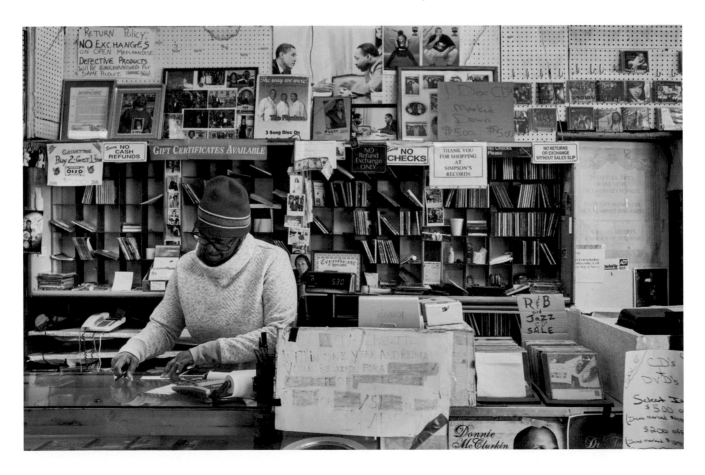

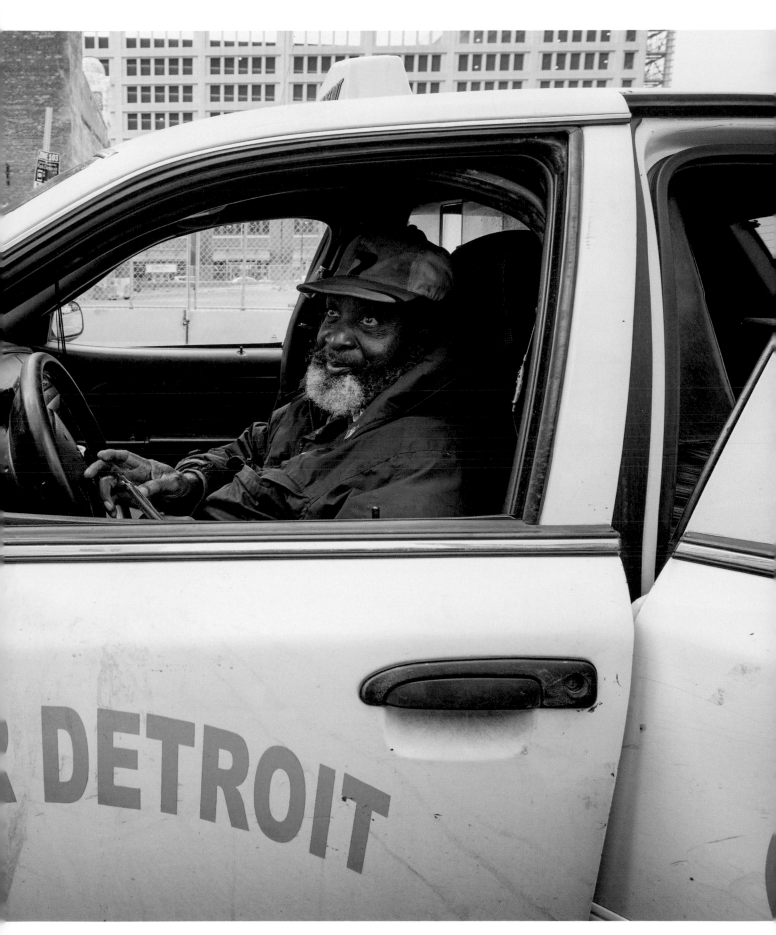

NIQUE LOVE RHODES

Dominique Campbell, Nique to her friends, lives in Lafayette Park. She is an only child, and her mother gave her a notebook to write down her thoughts. Poetry helped Nique through her rough childhood with a drug-addicted father. The poems she wrote eventually developed into rap, and Nique began a career as a performer. In her songs, Nique conveys a positive message; she doesn't want to impose negativity on the world.

From her apartment on the 19th floor, she looks over Downtown Detroit. It wasn't until she moved to this area two years ago that she discovered that it was once the flourishing black quarter of Black Bottom, a neighborhood that was demolished for the sake of urban renewal. She was baffled that this was never mentioned in history lessons and decided to do her own research.

Black Bottom was the most legendary neighborhood in Detroit. Its name derived from the dark color of the earth, because in the eighteenth century, it was mainly farming land. During the 1920s, black families worked their way up economically to the middle class of Detroit. There were hundreds of black businesses, which were needed because black people were not served in white stores.

Nationwide, the neighborhood became known for its lively music scene. John Lee Hooker visited, Aretha Franklin grew up there, and many well-known jazz musicians, such as Duke Ellington, Ella Fitzgerald and Count Basie, regularly performed in the neighborhood. But at the beginning of the 1960s, Black Bottom was designated for urban renewal. On the one hand, the Chrysler Freeway was constructed, which destroyed Hasting Street, a main thoroughfare. On the other hand, a complex of residential apartment buildings was erected. This wiped out an entire generation of Afro-Americans that was beginning to prosper. This discovery opened Nique's eyes. There has been so much urban renewal since the bankruptcy in 2013. Detroit is a gold mine for project developers. "Before we know it, there's Black Bottom 2.0."

Nique's greatest concern is the deterioration of education since the bankruptcy. She has noticed how more and more youngsters join gangs, not because they are raised in violent homes, but because there are no positive outlets for them. Public schools barely offer music lessons anymore, and that is why she and her band, The NLR Experience, began the Rise Up Higher Project, through which she wants to convert the positive messages in her music into tangible actions. She offers free workshops in schools that give youngsters a different, positive outlook, because "a zip code does not determine your life's outcome."

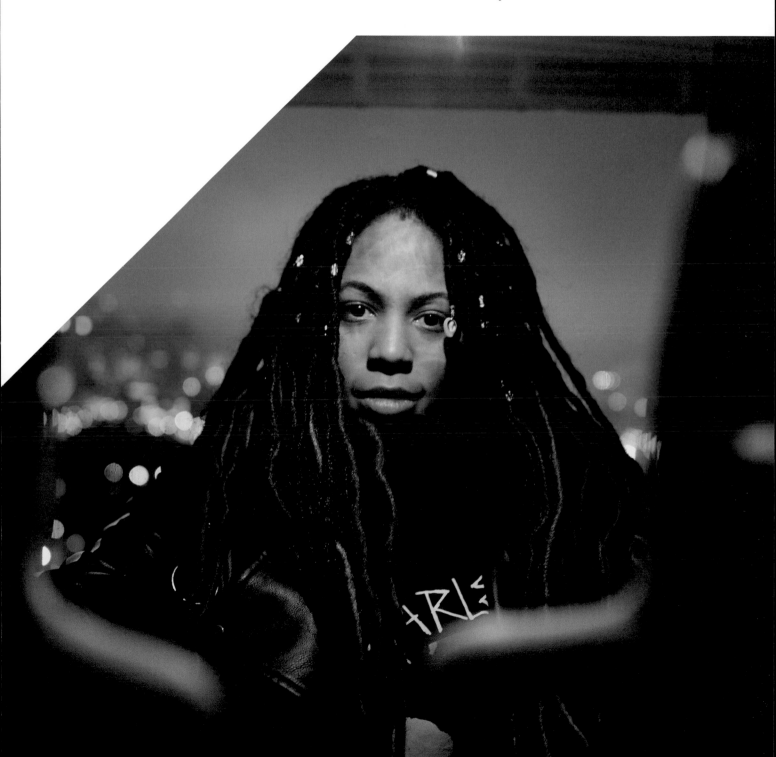

"A zip code does not determine
your life's outcome."

**This book is
MARKED**

MARKED is an initiative by Lannoo Publishers.
www.marked-books.com

JOIN THE MARKED COMMUNITY on @booksbymarked.

Or sign up for our MARKED newsletter with news about new and forthcoming
publications on art, interior design, food & travel, photography and fashion
as well as exclusive offers and MARKED events on www.marked-books.com.

Authors: Karel Van Mileghem & Mario Goossens
Editing Dutch texts: Michaël Van Damme
Translation: Bracha De Man
Editing English texts: Melanie Shapiro
Photography: Fabrice Debatty (all images, except p. 63 by Koen Keppens
and p. 44, 47, 59, 64, 66, 68, 70, 76, 86, 87, 88, 91, 101 by Sofie Hendrickx)
Graphic design: Nathalie Sternotte - oflua.com

Special thanks to:
Fabrice Debatty, Sofie Hendrickx & Leon, Nathalie Sternotte,
Michaël Van Damme, Niels Famaey, Sarah Theerlynck & everyone at Lannoo,
Olivier Goris & everyone at Canvas, Gerrit Kerremans, Radio1, Karl Everaert
& everyone at Panasonic, Everyone at PIAS, Everyone at Connections,
everyone at TV Connections, Peter Verstraelen, Herman Hulsens,
Chris Dusauchoit, Lucas Van den Eynde, Joris Thys, Hendrik Smeyers,
Janne Goossens, Hendrickx family, Van Mileghem family, Goossens family

If you have any questions or comments about the material in this book,
please do not hesitate to contact our editorial team: markedteam@lannoo.com.

© Lannoo Publishers, Tielt, Belgium, 2019
D/2019/45/500 - NUR 640/653
ISBN: 9789401464963
www.lannoo.com

#AREYOUMARKED